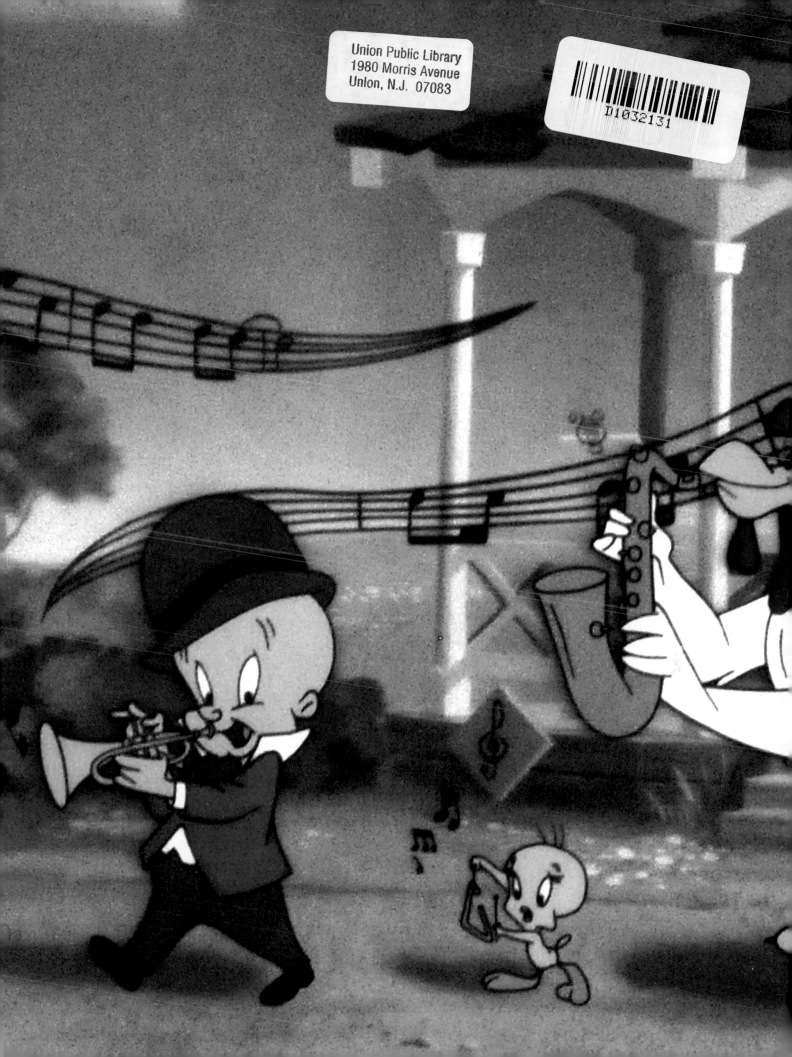

"I Say, I Say . . . Son!"

SANTA
MONICA
PRESS

Published by: Santa Monica Press LLC

P.O. Box 850
Solana Beach, CA 92075
1-800-784-9553
www.santamonicapress.com
books@santamonicapress.com

Printed in China

Santa Monica Press books are available at special quantity discounts when purchased in bulk by corporations, organizations, or groups. Please call our Special Sales department at 1-800-784-9553.

ISBN-13 978-1-59580-069-5

Library of Congress Cataloging-in-Publication Data

McKimson, Robert, Jr.
 "I Say, I Say . . . Son!" : A Tribute to Legendary Animators Bob, Chuck, and Tom McKimson / by Robert McKimson Jr. ; Foreword by John Kricfalusi.
 pages cm
 ISBN 978-1-59580-069-5 (hardback)
1. McKimson, Robert, 1910-1977—Criticism and interpretation. 2. McKimson, Thomas, 1907-1998—Criticism and interpretation. 3. McKimson, Charles—Criticism and interpretation. I. Kricfalusi, John, 1955- II. Title.

NC1766.U52M3836 2012
 741.5'80922—dc23

 2012010797

Cover image provided by Clampett Studio Collections.
Cover and interior design by Future Studio

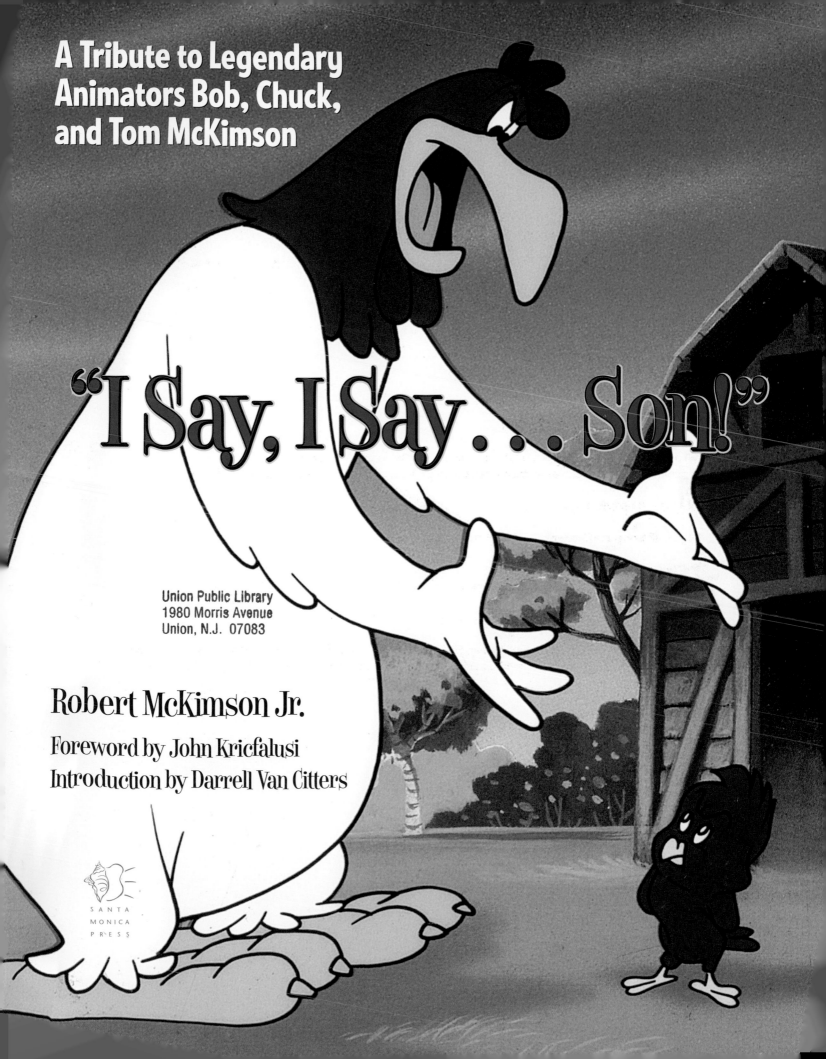

A Tribute to Legendary
Animators Bob, Chuck,
and Tom McKimson

"I Say, I Say . . . Son!"

Robert McKimson Jr.

Foreword by John Kricfalusi
Introduction by Darrell Van Citters

SANTA
MONICA
PRESS

This book is dedicated to the two women in my life:

Viola McKimson, my dear and wonderful mother, who saw to it that I was raised and schooled so I could move ahead not only in my chosen career but in life itself. I miss her every day.

Nancy, my wonder wife, whom I met late in life and who has not only supported me, but has been there whenever needed. There are not enough words to express my feelings for her.

Contents

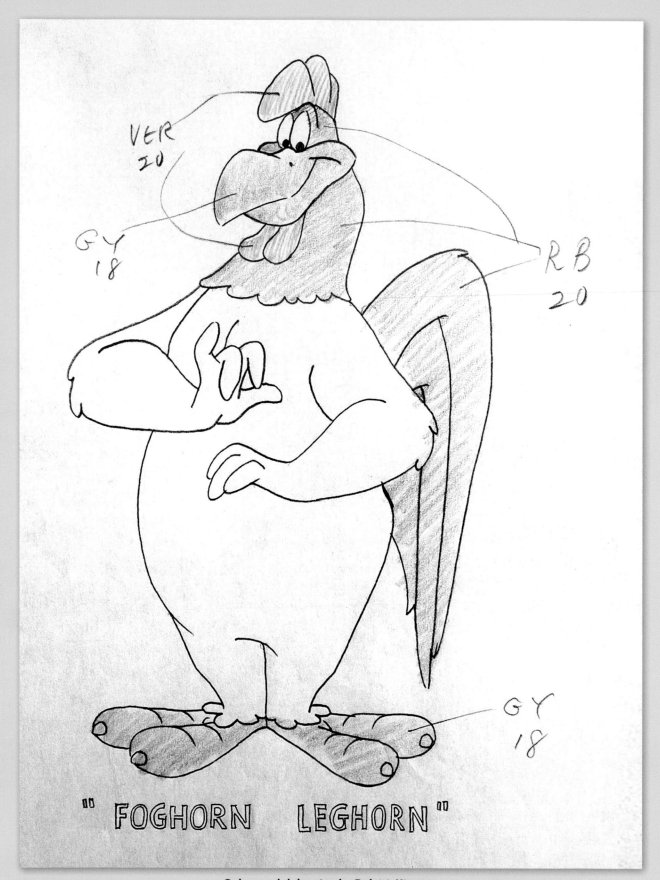

Color model drawing by Bob McKimson.

Foreword
by John Kricfalusi

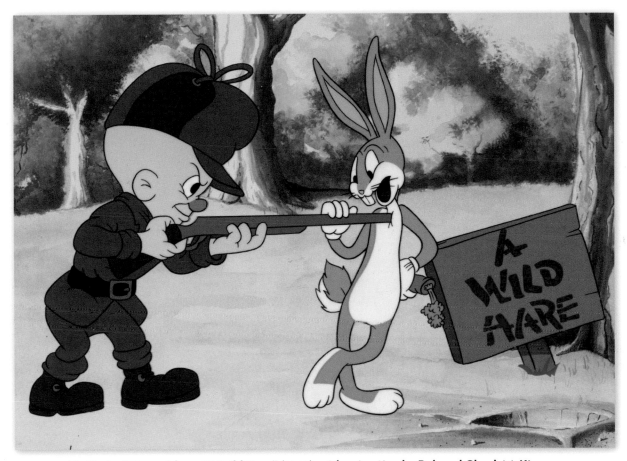

Limited edition cel from "A Wild Hare" (1940), with animation by Bob and Chuck McKimson.

Imagine how proud you would be to have one top animator in the family. Robert McKimson Jr. has three! He is the son of Robert McKimson, one of the greatest animators in history, and the nephew of Tom and Chuck McKimson, also wonderful animators and comic artists. Robert has written a touching tribute to his talented relations and tells us much about their early years and influences, as well as fascinating details about their work that are not generally known.

The style of animation from the 1930s to the 1950s was largely dominated by Walt Disney. The main alternative to Disney's sugary-sweet, sentimental cartoons was Warner Bros., whose loud, brash, and more individual work gave us not only funnier cartoons but also characters that were much more nuanced, specific, and believable.

Bob McKimson

While Disney's personality often overshadowed the contributions of his very talented animators, Warner Bros. allowed varied and unique talents like Tex Avery, Bob Clampett, and Chuck Jones to put their personal stamp on their work. Warner's animators and directors developed quirky individual styles that would have been buried at the larger and more homogenized Disney factory. But in the midst of all these personal touches and individual approaches, the studio needed a foundation upon which to build these variations. Bob McKimson was that foundation.

Bob as an Animator

One of my biggest personal heroes, Bob has to be one of the most important figures in animation history. He was the strongest draftsman at Warner Bros. (and maybe even in the whole industry), played the part of teacher in the studio, and was the anchor of the animation department. In the 1930s, the other directors relied on him as head animator to create the most difficult scenes and train the other animators. He did all this while cranking out the most footage of all the animators—50 feet a week, which was double the quota!

Bob developed his own unique way of animating that was less bouncy and floppy-looking than the Disney style. His animation was very direct and down to earth, and it was drawn solidly. He set the standard for the quality of Warner Bros. cartoons during the 1930s. The huge talents who became famous later all developed individual variations of Bob's basic style. Ken Harris (*The Pink Panther, How the Grinch Stole Christmas*) often said how grateful he was to Bob for teaching him to animate.

Bob did animation work for almost all the other directors at some point during the '30s—Chuck Jones, Tex Avery, Friz Freleng—and always turned out solid, impressive stuff. He animated the formative design for Elmer Fudd and Bugs Bunny in "Elmer's Candid Camera" and "A Wild Hare" (both released in 1940), setting the pattern for both the series and the studio itself.

I think Bob did his best animation work while in Bob Clampett's unit, from 1941 to 1944. I knew Clampett, and he told me with great reverence that Bob McKimson was his top animator and that he always gave him the most difficult scenes, the ones the other animators would be afraid to do. Clampett had a way of pushing his artists to do things beyond what they thought they could do on their own. He discovered that McKimson not only drew and animated very solidly, but that he had a photographic—and, even more astounding, a filmographic—memory.

Directors, including Clampett, usually drew many of the characters' poses for their animators and then left it up to the animators to polish the work. In Bob's case, Clampett took advantage of his extra sensory power. Instead of giving him drawings to work with, Clampett acted out the scenes live in front of Bob. This resulted in a more nuanced and "realistic" sort of animation. As he watched Clampett perform, Bob memorized every little subtle expression and human gesture, then turned around and animated the whole thing perfectly. One example of this remarkable new kind of "animation acting" is "Falling Hare" (1943), in which Bugs Bunny sits on the wing of a plane in a relaxed pose and reads a "fairy tale" about gremlins sabotaging planes.

One of the hardest things to animate is a character moving slowly. Facial features tend to float around the head and detach themselves from the form. But Bob seemed to relish this most difficult task. Add to that the extra impossibility of animating subtle and realistic facial expressions, body language, and hand gestures, as opposed to the floppy, squashy-stretchy style of animation that purposely avoids difficult drawing, and you get a completely new kind of animation, one that I've only seen in Clampett-McKimson team-ups.

It was this revolutionary kind of animation that largely contributed to Bugs Bunny's personality,

and Elmer Fudd's, for that matter. Bob's subtle animation of Bugs pretending to die in Elmer's arms in "A Wild Hare" is classic, one of the funniest scenarios in cartoon history, so funny that both Avery and Clampett used it, and always had Bob animate it. I don't know anyone else who could have pulled it off.

Bob is also known for his dynamic and solid posing and wildly exaggerated perspective. He could animate characters leaning toward and away from the camera while still controlling all the dialogue acting and overlapping arm gestures. He animated the best Hitler ever in Clampett's "Russian Rhapsody" (1944). In the cartoon, Hitler is delivering a typically nutty speech, pounding the podium and leaning forward as he sputters and drools on his audience before rearing ridiculously far back to anticipate the next forward lean. Bob exaggerated the perspective in his acting beyond what you would think is possible and used that technique to great effect later in his Foghorn Leghorn cartoons. Even as a kid, I always looked forward to those scenes and used to imitate them to entertain my friends. I didn't know at the time who had invented them.

One of the most amazingly difficult and entertaining scenes ever animated is in the now-controversial *Merrie Melodies* cartoon "Coal Black and de Sebben Dwarfs" (1943), which features the Queen riding a candy apple wagon to deliver the poison apple. First of all, it's difficult enough to animate a figure riding a bike. But this bike is bouncing up and down to the cartoon's music with a bunch of bells attached to it, all tinkling and swaying in opposing and overlapping action. To top it all off, the huge queen is wearing a big-nosed mask that she takes off while riding the pulsating

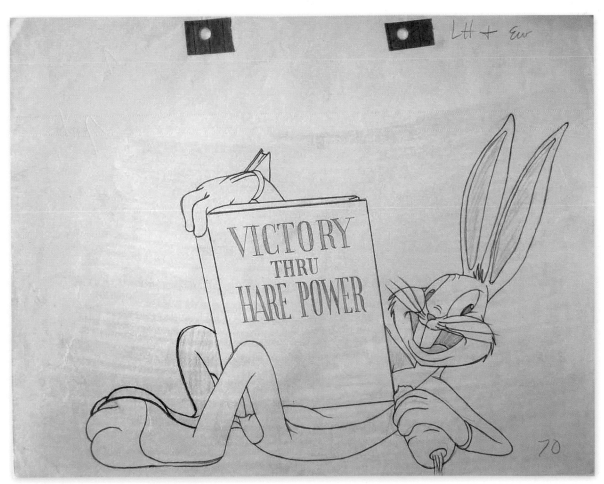

Animation drawing for "Falling Hare" (1943) by Bob McKimson.

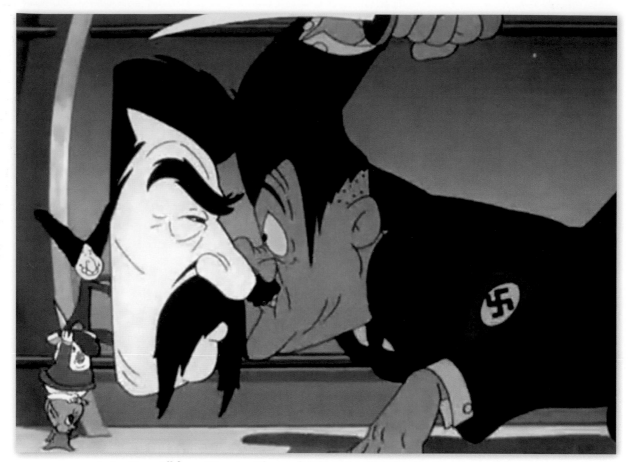

Animation still from "Russian Rhapsody" (1944), with animation by Bob McKimson.

bike, turning to the camera to do an impression of Jimmy Durante. There is so much going on in this scene that I can't imagine how we are able to take it all in at once and how it remains perfectly solid and beautifully acted at the same time. This is a one-of-a-kind scene that only Bob McKimson could have animated. I don't think any of Disney's famed "Nine Old Men," even, could have pulled off something that difficult.

Bob as a Director
Bob also contributed much to the studio and its roster of great characters through his directing. First of all, he carried on the raucous style that made Warner Bros. so popular in the 1940s much longer than other directors did. This even continued into the early '50s, when most cartoons were calming down, using less animation, and relying more on dialogue and sedate actions.

The most unique thing about Bob's cartoons is how masculine they are. They seem to be aimed at what dads would think is funny. My own dad used to watch *The Bugs Bunny Show* with me and always laughed the hardest at Bob's cartoons. They had everything he found entertaining: loudmouthed characters, pushing and shoving, accidents with dangerous tools, and fierce, obnoxious competition between testosterone-filled characters. These cartoons were so different from Disney's more effeminate approach (Disney admitted that he aimed his cartoons at mothers) and the artsy-fartsy cartoons that the '50s ushered in. I think Bob, more than any of the other directors after Clampett, aimed directly at the widest possible audience of regular folks.

You know it's a great cartoon if kids want to act it out. We used to memorize our favorite

comedy albums by Bill Cosby, Allen Sherman, and Cheech and Chong, or the funniest scenes from sitcoms like *Get Smart,* and then act them out in the schoolyard. Some cartoons we replayed over and over were "Hillbilly Hare" (1950), in which Bugs Bunny sings a crazy square dance tune for two moronic hillbillies who obey all the painful lyrics. Honestly, that has to be one of the funniest films in history, live *or* cartoon. We also acted out the wolf and pigs in "The Windblown Hare" (1949) and Peter Lorre in the 1947 hit "Birth of a Notion" ("Why did you heet me in de head,

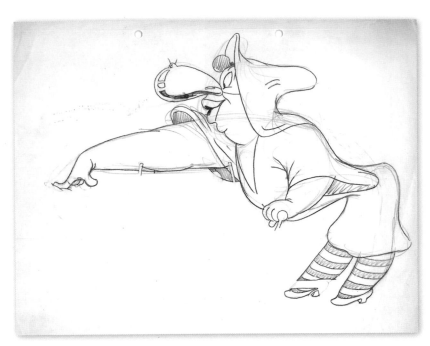

Leopold? Donchoo know det could make me verrrry angry, ah could do terrible, horrible tings to you . . . "). I forget which Tasmanian Devil cartoon we played out, but I'll never forget the line: "What for you bury me in de cold cold ground?" Of course, all the kids loved to act out Foghorn Leghorn: "Pay attention to me, boy, I keep pitchin' 'em and you keep missin' 'em!" We used to shove and manhandle each other like McKimson characters did to each other.

Bob had a really funny assessment of humanity that he projected through his cartoons—pretty much every male character was, shall we say, less than gentlemanly. They were all greedy and out to swindle and take advantage of each other. I love the way he teamed Porky and Daffy. In the other directors' cartoons, Porky is generally a naive, milquetoast sort of character. But in Bob's cartoons, he is a *jaded* milquetoast who has been around the block and knows everyone is out to swindle him—especially that obnoxious pest, Daffy Duck. "Thumb Fun" (1952) and "The Prize Pest" (1951) are hilarious cartoons and purely Bob McKimson.

Foghorn Leghorn, of course, is Bob's greatest character, and may be the funniest of Warner

Above: Animation drawing for "Coal Black and de Sebben Dwarfs" (1943) by Bob McKimson.
Below: Lobby card for "Coal Black and de Sebben Dwarfs," with animation by Bob and Tom McKimson.

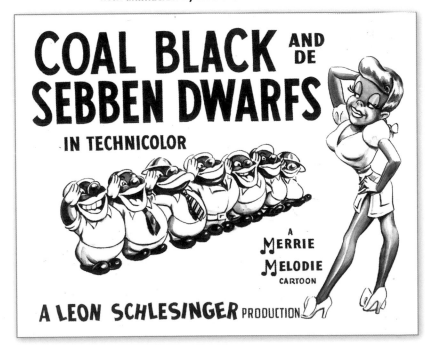

Above: Animation still from "Hillbilly Hare" (1950), directed by Bob McKimson
with animation by Chuck McKimson.
Below: Original comic book art by Tom McKimson, 1980.

Bros.' fantastic cartoon cast. My dad would perk up when the title card of a Foghorn cartoon came up on *The Bugs Bunny Show*. "Who's that? The big *chicken*? I love that guy!" He would laugh so hard at Foghorn's antics that his glasses would fly off his head and tears would well up in his eyes as he pounded the arms of his chair and stomped the floor with his slippers.

I could go on and on about Bob's stellar talent and his contributions to our history and great influence on me personally, but this is just a foreword. The book will tell you more.

Tom & Chuck McKimson

My favorite cartoons of all time are Bob Clampett's 1940s films. Coincidentally, Clampett had not only Bob McKimson working on them, but also his brother, Tom McKimson.

Tom was one of Clampett's layout men and character designers who worked on some of Warner Bros.' greatest cartoons. Clampett told me that Tom was his closest collaborator and that they hung out a lot after hours and went to movies together to get ideas for their cartoons. I interviewed Tom once and he told me he had had so much fun working with Clampett that after the director left the studio in 1946, Tom decided to quit animation altogether. This book reveals that this was just about the time Tom

"I Say, I Say . . . Son!"

started working for Western Publishing's Dell Comics.

I personally don't know that much about Chuck McKimson, except what animator Greg Duffell (*Inspector Gadget*) has told me and what I've read in this book. It turns out that a lot of my favorite animated scenes in Bob's cartoons—scenes I thought Bob himself had animated—were actually animated by Chuck. I guess they really were that much in sync.

When I was a kid, I was hugely influenced by Tom and Chuck McKimson without even knowing it! I taught myself to draw by copying cartoon characters out of Dell and Gold Key comics, Whitman coloring books, and Little Golden Books. One of my favorite Golden Books was *Bugs Bunny*, which had beautiful drawings by Tom and paintings by Disney background painter Al Dempster. Little did I know at the time that Tom and Chuck were both art directors at Western Publishing, where they not only drew their own books but art directed many of my other favorite cartoonists and illustrators.

This book details some of the history of the brothers' work for Western. One of my favorite stories in here is the one about Tom meeting and working with some of Hollywood's prettiest starlets, like Liz Taylor and Dinah Shore, to draw them in their undergarments. Nice perks working at Dell Comics!

I found it especially interesting to read about Tom working not only on the *Looney Tunes* comics but also on the Disney, MGM, and Lantz books. Chuck was the art director for Dell when they did the beautiful Hanna-Barbera comics drawn by Harvey Eisenberg, Pete Alvarado, and others.

With this book, the McKimson brothers finally get some long overdue recognition for their talent, dedication, and hard work. They have had a huge influence on me and certainly on scores of cartoonists who may have not even heard their names before.

Enjoy reading about these three dedicated artists who contributed so much to the wacky world of cartoons!

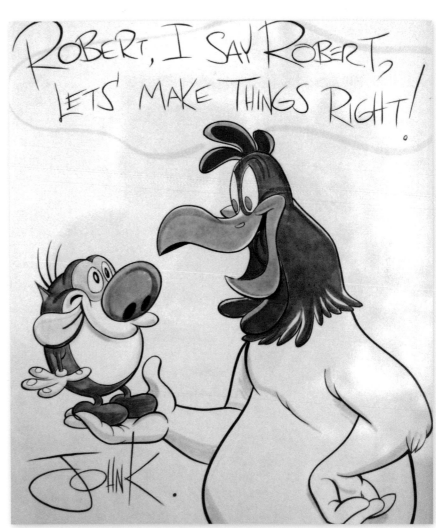

**Mixed media drawing by John Kricfalusi in tribute to
Bob McKimson, featuring Foghorn Leghorn and Stimpy from Kricfalusi's
cartoon series, *The Ren and Stimpy Show*.**

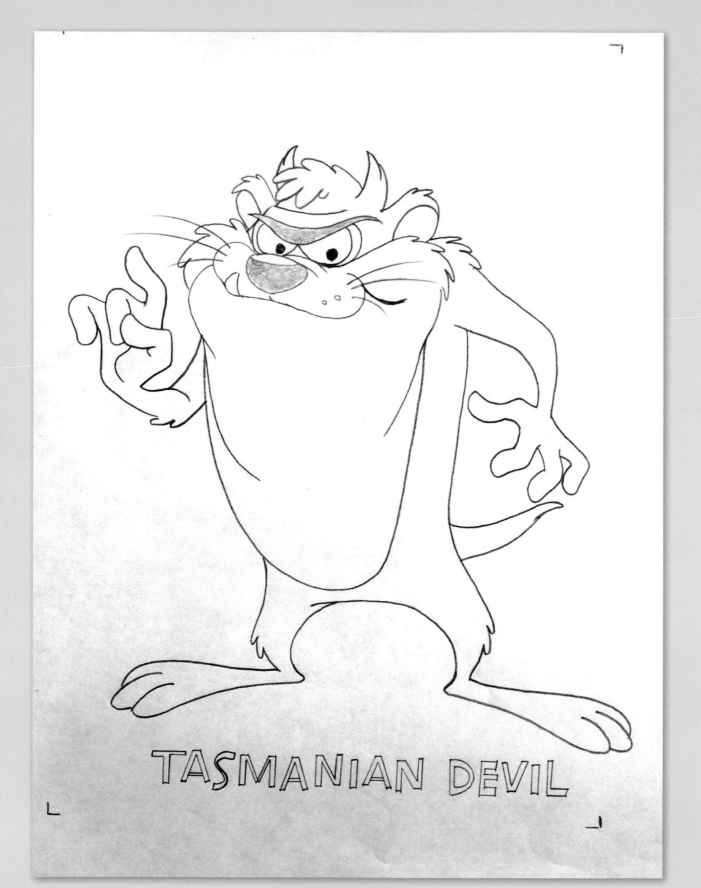

TASMANIAN DEVIL

Drawing by Bob McKimson.

Introduction
by Darrell Van Citters

Animation still from "The Hole Idea" (1955), directed and animated by Bob McKimson.

Generations of people around the world instantly recognize Foghorn Leghorn or the Tasmanian Devil, but how many can name the man who created the characters and directed their cartoons? The answer is Robert McKimson, probably the most underappreciated of all the Warner Bros. cartoon directors.

In the studio's heyday, Chuck Jones and Friz Freleng would clamor for recognition, leaving the much more modest Bob in a distant third. Although he had a major impact on the look of the studio's product during its Golden Age and played a vital role in the creation of its characters, Bob unfortunately died much earlier than most of the other directors, leaving his legacy silent when theatrical animated cartoons experienced a renaissance of renewed interest in the 1990s. Bob did not have publicity machines touting his contributions the way directors like Jones

Original pen-and-ink drawing by Tom McKimson for *Mouse Tales*, 1928.

Chapter One
Aspiring Artists

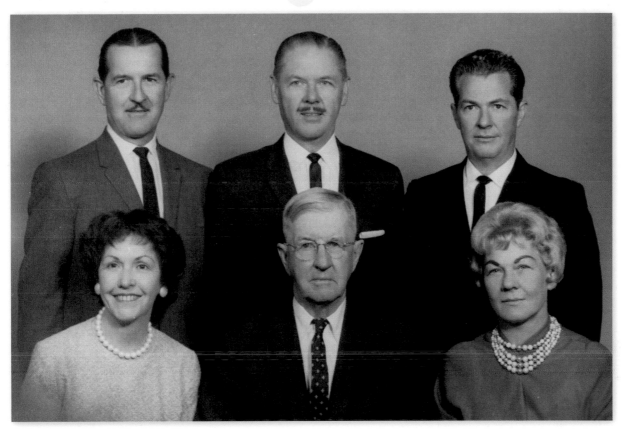

Front row: (left to right) Anabel, Charles Sr., and Alyce McKimson.
Back row: (left to right) Bob, Tom, and Chuck McKimson.

My uncle, Thomas "Tom" McKimson, the eldest of three brothers who were to play a significant role in the evolution of animation and comic book art, was born on March 5, 1907. He was followed by my father, Robert "Bob," on October 13, 1910, and my uncle, Charles "Chuck" Jr., on December 20, 1914. Their parents, Charles and Mildred Porter McKimson, also had two daughters, Anabel and Alyce. The entire family was born in and around Denver, Colorado, where Charles Sr. worked as a regional newspaper publisher. Over the years, he published newspapers not only in the Denver area, but also in West Texas and Kansas. The boys worked with my grandfather at the newspaper, doing various jobs including linotype work and, from time to time, illustrations.

It was their father's belief that the boys should be trained in a profession at an early age, even if they eventually chose not to pursue that career. My father and uncles were natural-born artists, a talent inherited from their mother, who had never exploited her own artistic ability. Mildred taught the boys all she knew about drawing from the time they could hold a pencil. Prior

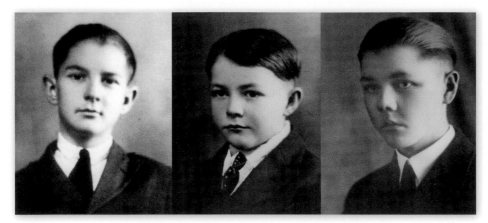

Bob, Chuck, and Tom McKimson as teenagers.

to moving to California, the brothers' drawing experience was confined to newspaper cartoons, state and county fair art exhibitions, and artwork they made just for fun.

Bob's initial schooling took place in a small country schoolhouse in Wray, Colorado, where eight elementary grades were taught in one large room. The family briefly moved to Los Angeles, California, in 1921 before heading back to Colorado and then to Canadian, Texas, where Charles bought and ran a newspaper. Finally, in 1926 the family moved back to Los Angeles, where Charles Sr. began publishing a local newspaper.

In 1927, while his younger brothers and sisters attended Manual Arts High School, Tom enrolled at the University of California at Los Angeles (UCLA), which had first opened its doors in 1919. Tom had looked forward to taking classes in the university's commercial art program but found that the courses it offered did not meet his expectations. He decided to transfer to the Otis Art Institute and enrolled in a more appropriate program there that included color painting and drawing from life. In 1929, Tom left Otis to work full-time, but considered the experience a good basic background for his future pursuits.

Tom's younger brothers were also embarking on their artistic careers. After graduating from high school, Bob worked as a linotype operator in Hollywood. He too had artistic aspirations, though he wasn't receiving any formal art training at the time. Chuck's original plan had been to take over the newspaper business from his father, where he had trained as a printer from the age of eight, feeding newsprint into the printing presses. However, he was later encouraged to enter animation after his brothers began working in the field.

From 1927 to 1928, Tom and Bob illustrated a proposed children's book, *Mouse Tales*, which

Tom McKimson (inset and middle row, ninth from right) as a student at Otis Art Institute, 1927.

"I Say, I Say . . . Son!"

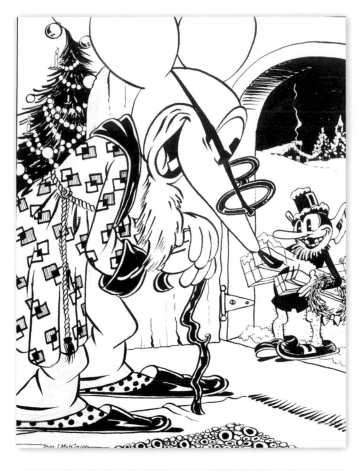

had been written by their mother. Their drawings, which featured various cartoons that were similar to Disney characters in many ways, were stored away in the 1930s and only rediscovered in the mid-'90s. It is plain to see from these early examples why Tom and Bob became so adept at creating characters and model sheets later in their careers.

Few animators in the early cartoon studios had fine art backgrounds and were only capable of animating simple shapes. Although Chuck chose not to attend art school, Tom, Bob, and others like them—such as Chuck Jones—had aspirations to acquire a fine art background. As the animation and cartooning industry grew, it was necessary for the artists to improve their skills. The brothers were fortunate to get fine art training at local art schools and study with individual instructors in order to develop their own unique artistic talents.

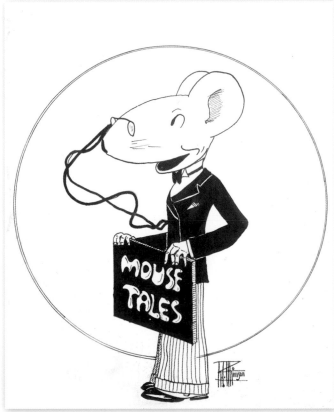

Pen-and-ink drawings by Tom (above left) and Bob (left and above right) McKimson for *Mouse Tales*, 1928.

Animation drawing of Binko, 1931.

Chapter Two
Becoming Animators
1929-1931

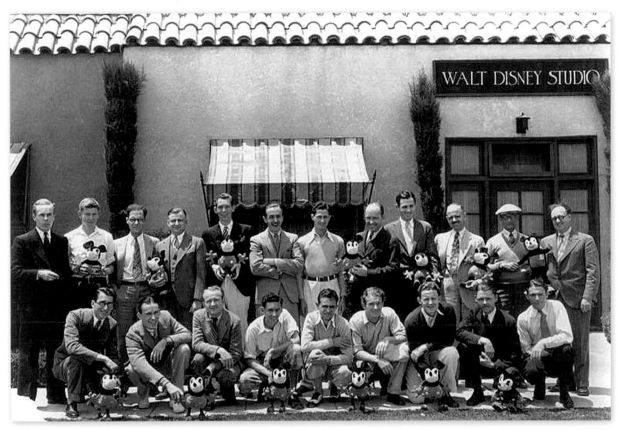

Tom (front row, second from right) with the Walt Disney Studio staff, 1929.

In 1929, while Chuck was finishing up high school, Tom and Bob joined the cartoon studio at Walt Disney Productions. Originally founded in 1923 by Disney and his brother, Roy, the studio was located in Los Angeles, first on Kingswell Avenue, then on Hyperion Avenue before moving to its present Burbank location in 1939.

There are two versions of how the McKimson brothers came to be employed at Walt Disney Productions. Tom remembered that there were several Disney animators attending the Otis Art Institute with him and that they suggested he apply there for a job. Bob, on the other hand, recalled that his aunt, who had been visiting from Denver and often rubbed elbows with celebrities, had met Walt Disney at a party and mentioned that two of her nephews were artists. Disney had replied, "Tell them to get over to my studio and I'll give them a job."

Tom immediately went to see Disney with samples of his artwork and was hired on the spot. Bob, who was still working as a linotype operator, met with Disney two weeks later and was also given a job. The brothers were both hired as assistant animators at $18 per week; after three

Romer Grey (left) with his father, Zane, circa 1930.

months their pay was raised to $25. According to Bob, no more than 30 people were employed at the studio, which included nine animators, each with an assistant. Disney was closely involved in all aspects of the cartoons and approved every pencil test.

Tom first worked as an assistant to Norm Ferguson on the *Silly Symphony* series, which was new at the time. Bob's first assignment was as an assistant to Dick Lundy on "The Chain Gang," which was released two years after "Steamboat Willie" (1928), the first animated cartoon to have a fully post-produced soundtrack. His first animation was a Mickey Mouse walk-on. He had to animate Mickey's walk three or four times due to the buttons on the mouse's pants riding up and down just a little too much or not quite enough.

Walt Disney Productions had already broken ground with "Steamboat Willie." In 1932, the studio made history once again, producing the first film to use the full-color, three-strip Technicolor process, "Flowers and Trees." Disney put Technicolor on the map, signing an exclusive three-year contract with the company that was later changed to a one-year contract when other major studios decided to use the three-color process in place of the traditional two-color process.

The brothers continued their work at Disney until 1930, when they resigned to pursue a new opportunity. Walt had offered to double their salary, but it wasn't enough; due to their father's financial downturn, Tom and Bob now had to support the family. At the time, neither Bob nor Tom had any idea that Walt Disney Productions would eventually become the most influential company in the animated cartoon industry.

Animation drawing of Binko, 1931.

Earlier that year, Bob and Tom had met Romer Grey (the son of famed Western novelist Zane Grey), who was gathering together a fledgling group of animators for his new studio. The brothers began to work with Romer on nights and weekends while still animating for Walt Disney Productions. Romer Grey Pictures, Ltd. was officially launched in the spring of 1930 and was quartered on the grounds of the Grey family home in Altadena, California, where Romer lived with his parents. The studio was financed with a loan from Romer's father and other funds raised by his mother. Romer, who possessed no artistic ability, hired Volney White as the studio supervisor and Tom and Bob as head animators, paying each of the brothers $80 per week.

Despite their youth, both Tom and Bob had more experience than most of the other artists who signed on at the studio later. This group included Jack Zander and Pete Burness, who were in class at the Chouinard Art Institute when a call came in from Romer requesting artists to work in his studio over the summer. Zander and Burness claimed to be animators, even though they had no idea what the job entailed. Artists Preston Blair, Ken Harris, Cal Dalton, Bob Stokes, and Paul Allen were also hired with no experience in animation, but they all eventually became successful cartoonists. At the height of its activity, the studio had about 25 employees. Five of these artists were named Robert, so Bob became known as "Buddy," his family's nickname for him.

The McKimson brothers developed the studio's main character, Binko the Bear Cub. As Jack

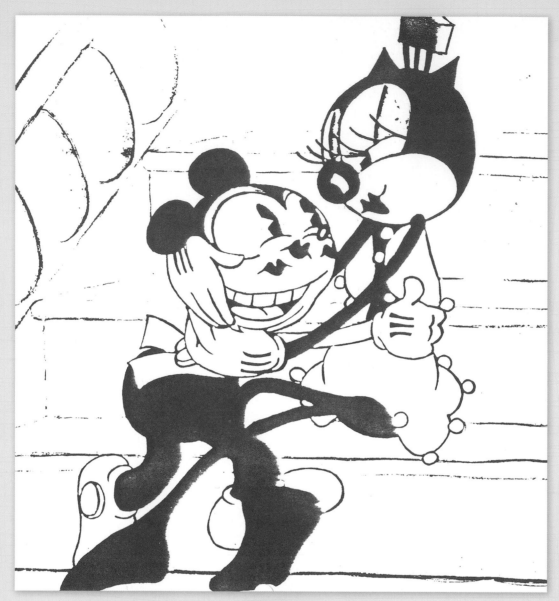

Publicity drawing for "Hot Toe Molly," 1931.

Binko the Bear Cub

With his rounded ears, large eyes, and cheerful character, Binko the Bear Cub bore a strong resemblance to Mickey Mouse. Developed by Tom and Bob McKimson, Binko was featured in four cartoons that were created and remained in some form of completion before Romer Grey Pictures closed in 1931: "Arabian Nightmare," "Hot Toe Molly," "Binko the Toreador," and "Sand Witches."

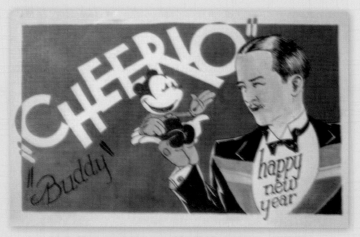

New Year greeting card by Bob McKimson, 1929.

"I Say, I Say . . . Son!"

Zander remembered, the only differences between Binko and Mickey Mouse were their ears and Binko's lack of a tail. But it was in the supporting characters that they strayed from the formula, producing some drawings that were 10 or more years ahead of their time.

Unfortunately, funding problems arose and Romer was only able to pay the artists on an irregular basis. Since they were not being paid consistently, Tom and the other artists started charging their lunches to the Grey family's account at a local drugstore. However, Romer's mother soon saw the bills and put a stop to the lunches.

Romer's studio eventually closed in 1931. Four cartoons had been created, two of which were complete and ready for filming. The original plans had called for the finished cartoons to be filmed in color; although this was later downgraded to black and white due to budget constraints, the plans were never set in motion and the cartoons remained incomplete.

Grey's determination to remain independent was his undoing. Had he partnered with a major studio in order to obtain capital and distribution, his studio might have become quite successful. His claim to fame, however, remained that he was the son of Zane Grey.

In 1990, a plumber working in the basement of the former Grey residence in Altadena discovered the remains of Romer Grey Pictures, including animation drawings, exposure sheets, production records, cels, and even musical scores. In lieu of payment for his work, the plumber took possession of the entire contents of the basement. That artwork, with the help of many cartoon historians, has been researched and preserved and is now held by Binko Animation Art.

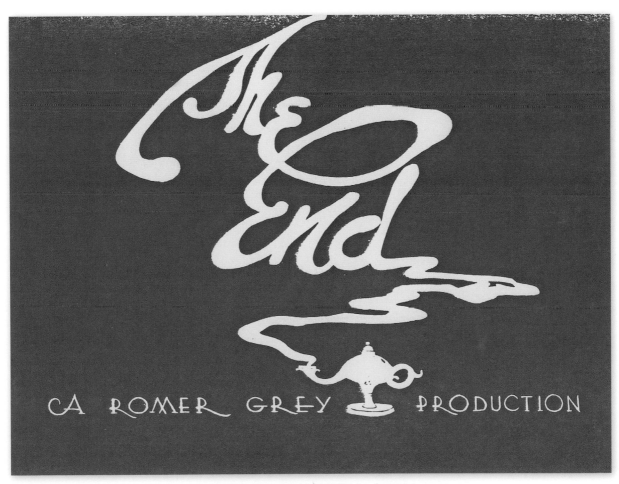

Romer Grey Pictures title card, 1931.

Animation drawing of Bosko.

Chapter Three
Harman-Ising Productions
1931-1933

Harry Warner (second from left) and Leon Schlesinger (far right) with friends, circa 1930.

After Romer Grey Pictures closed in 1931, Bob and Tom went on to work as animators for Hugh Harman and Rudolf Ising, the animation team that had started their own studio, Harman-Ising Productions, in 1929. Harman and Ising had both worked with Walt Disney in the '20s at his studio in Kansas City and later in Los Angeles. In 1930, they had signed an agreement with a middleman, Leon Schlesinger, who arranged for their cartoons to be released through Warner Bros.

Harman-Ising's first series of cartoons, debuting in 1930, was called *Looney Tunes*, derived from Disney's *Silly Symphony* series. "Sinkin' in the Bathtub" was the first commercial episode to be released, featuring a new character named Bosko. The McKimson brothers' first animation screen credits were for cartoons featuring Bosko—Tom's appeared in "It's Got Me Again!" and Bob's was in "Bosko's Store," both released in 1932.

Above: Animation still from "Bosko and and Honey," 1932.
Below: Publicity drawing for "Big-Hearted Bosko," 1932.

Animation still from "Bosko in Person" (1933), with animation by Bob McKimson.

Bosko

Bosko's creation goes back to 1927, when both Hugh Harman and Rudolf Ising were still with Walt Disney. The two animators created the character for the new "talkie" motion pictures that were just starting to come out. Disney ultimately decided not to use Bosko, so Harman and Ising registered the character after leaving Disney in 1928. In 1929, they produced a short pilot cartoon called "Bosko the Talk-Ink Kid" that featured Bosko, a character that "came to life" when drawn on paper and "returned to the inkwell" once the cartoon was over. This short had no plot but was the first cartoon to include synchronized speech. Bosko made his official debut the following year in "Sinkin' in the Bathtub."

Known for singing, dancing, and playing various instruments, Bosko soon became the star of Harman-Ising's new *Looney Tunes* studio. He wore white pants and a derby hat and was often accompanied by his girlfriend, Honey, and a dog by the name of Bruno. Bosko would go on to star in 37 *Looney Tunes* cartoons.

Animation drawing for "Bosko the Doughboy," 1931.

Above and opposite: **Animation stills from "The Dish Ran Away with the Spoon" (1933), with animation by Bob McKimson.**

This outstanding first impression demonstrated to everyone in the Harman-Ising studio that the McKimsons were there to do serious work, unlike many other cartoonists there during that period. The brothers were better organized than the others and had a different way of animating. Bob was able to produce a clean drawing without the aid of guidelines, which most of the animators needed. Some of their co-workers called the brothers "the Mechanical McKimsons."

Typically, Bob could draw 25 to 30 feet of animation per week. But after an automobile accident in 1932, in which some nerves in his neck were pinched when he was thrown from the car, Bob was somehow able to double his output. None of the doctors could give an explanation for what had happened. They said the accident had probably jarred something loose in his brain. Over the following 10 years, Bob averaged 55 feet of animation per week, an unheard-of quantity. At the time, the cartoonists' union classified animators by their level of expertise and would not classify Bob with anyone else, since no other animator could match his production.

Bob could also visualize and draw pictures as they were described to him. It was fascinating to watch him begin a drawing from any direction and have the illustration always come out the

same. I can remember, on many occasions, seeing my father do a fast drawing and never retrace a line. He also had a habit of sharpening his pencil, not with a sharpener, but with a piece of paper attached to the side of his lighted animation board.

While Bob and Tom were at Harman-Ising, Chuck often came to the studio to pick them up from work. Chuck, who had taken art classes in school, had accumulated a portfolio of drawings. Eventually, the producers asked to see his work, and the studio hired him in the mid-1930s.

In the early 1930s and up until the beginning of World War II, Bob studied fine art, starting with a semester at the Chouinard Art Institute with Don Graham. In 1932, Walt Disney commissioned Graham to teach evening classes at his studio to improve his artists' drawing skills. Graham's theory was: "A drawing principle is a drawing principle. If it works in a Rubens, it must work in Donald Duck. If it works in the Duck it must work in Snow White." Bob spent most of his class time talking about anatomy with Graham, who was impressed that Bob, unlike the other students, had a real understanding of the subject.

Bob's next tutor was Theodore Lukits, a well-known portrait painter in California who painted many famous actors and actresses of the silent film era. He was also a gifted plein air painter,

muralist, and prominent teacher who taught for more than 60 years. Bob's natural ability as an artist, paired with his experience working alongside this master painter for 10 years, contributed to his expertise not only in cartooning, but also in fine art. Bob became an accomplished portrait

**Pastel artwork by
Bob McKimson, 1945.**

painter who knew every bone in the human body and could spend several hours just working on a hand. In my possession are several pieces of fine art drawn or painted by my father, dating from the mid-1930s and into the '40s, that include life drawings he did while studying under Lukits.

Publicity drawing by Bob McKimson.

Chapter Four
Leon Schlesinger Productions
1933-1944

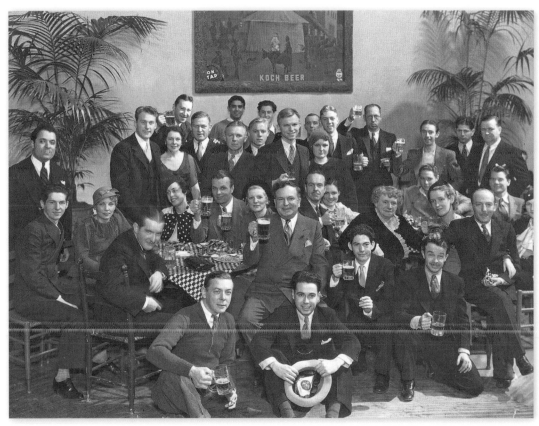

Bob McKimson (seated, fourth from left) at a Leon Schlesinger Productions party, mid-1930s.

In 1933, Harman-Ising and Leon Schlesinger went their separate ways. That year, Schlesinger opened his own studio and began to release cartoons through Warner Bros. Apparently, Hugh Harman had been seeking more money from Schlesinger in order to improve the quality of the cartoons and make the transition to color. Schlesinger did not want his profits cut, so they parted ways. Harman-Ising then switched to MGM for their film distribution and took their main character, Bosko, with them. This left Schlesinger with no characters; however, he still owned the phrases "Looney Tunes," "Merrie Melodies," and "That's All Folks!"

Bob decided to move to the new Leon Schlesinger Productions as an animator, along with Friz Freleng and some of the others. Tom stayed with Harman-Ising, mainly because he liked the working conditions and did not want to move. Because the cartoons often ran overbudget, MGM ended its relationship with Harman-Ising to establish its own animation studio. When that happened, Tom left to work with other studios until he eventually joined Leon Schlesinger Productions in 1939. Chuck, who had begun his cartooning career with Harman-Ising in the mid-1930s,

also joined Leon Schlesinger Productions after the split with MGM. His first screen credit was "Land of the Midnight Fun" (1939). He would remain there until he joined the U.S. Army in 1941.

Leon Schlesinger Productions began business on the old Warner Bros. backlot off Sunset Boulevard in Hollywood, using a building that was part of Warner Bros. Vitaphone. After a while, they expanded their studio to include a second building, which was called "Termite Terrace" due to a thriving infestation. In 1938, it moved a short distance away to a two-story building on the corner of Van Ness and Fernwood, where it remained until 1955. On the first floor were the offices of Schlesinger and production manager Ray Katz, as well as the ink and paint department, a conference room, a projection room, a camera room, and areas for Friz Freleng's and Chuck Jones's units. A storage room, special effects room, and, later, Bob McKimson's unit, were located on the second floor.

Leon Schlesinger was a dapper man who wore a carnation in his lapel, used a great deal of cologne, and attended the horse races frequently during the season. It has been suggested that the famous Warner Bros. character, Porky Pig, was based on Schlesinger, whose speech impediment (a lisp) inspired the cartoon pig's stutter. Schlesinger was the former head of Pacific Art and Title, which made dialogue cards for silent movies. He was closely acquainted with the Warner brothers. It is believed that he helped finance Warner Bros.' first talking picture, *The Jazz Singer,* released in 1927. Jack Warner suggested that Schlesinger move into the cartoon business, since the days were numbered for dialogue cards. As a first step, Schlesinger made the agreement with Harman-Ising to release its cartoons through Warner Bros., with himself as the middleman. He was reported to be a tough businessman and closed the studio on two occasions in the early 1940s when his newly unionized employees made demands for more pay.

Schlesinger prided himself on employing only the best, allowing them to develop their own methods and try out new ideas. Shortly after opening his studio, he instituted the unit system that solidified the staff into different groups, each with its own director. Each individual unit was then able to develop its own particular style. Every Monday morning, Schlesinger visited the story department of each unit and asked, "Well, boys, what are you working on today?" The answer was, invariably, "A farm picture with incidental gags." Schlesinger would then reply, "Good, good, keep it up." Schlesinger liked to personally hand out the paychecks on a weekly basis, but due to his extensive use of cologne, his employees needed to wash their hands after he had delivered them.

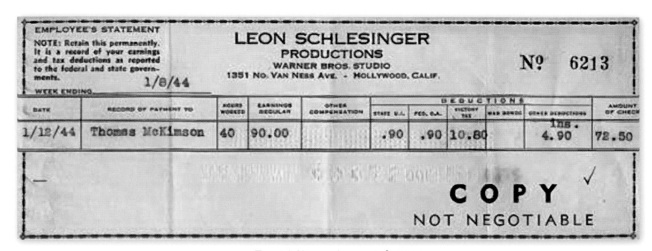

Tom McKimson's pay stub, 1944.

"I Say, I Say . . . Son!"

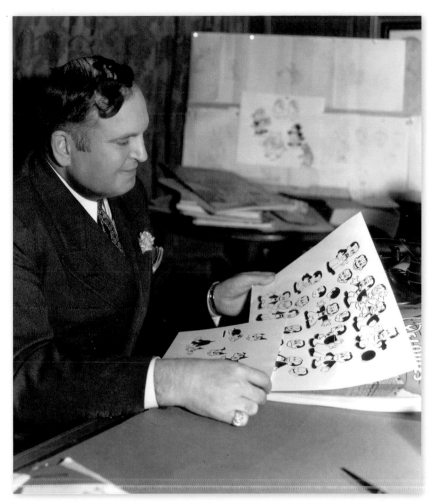

Leon Schlesinger, mid-1930s.

In the beginning, there were four directors at Leon Schlesinger Productions: Jack King, Earl Duvall, Tom Palmer, and Friz Freleng. Palmer soon left, however, and Freleng took over most of the directing. Also joining the studio at its start were animators Bob Clampett, Chuck Jones, Melvin "Tubby" Millar, and Ben Hardaway. Tregoweth "Treg" Brown also transferred from Harman-Ising as an editor and sound effects man. He recorded new sounds for each cartoon and then saved them for use in future films. His imaginative use of sound effects was a significant factor in the success of Warner Bros. cartoons.

Schlesinger considered Bob McKimson to be the fastest animator in the studio, and they had an excellent rapport. During the mid- to late-1930s, Bob was earning $150 plus per week, when the pay scale at the studio started at about $6 per week. I can remember my father getting a very expensive watch from Schlesinger in 1944, when he sold the studio to Warner Bros.

The studio soon developed a new character, Buddy, who was featured in 23 cartoons from 1933 to 1935, but ultimately proved to be unpopular. It's possible that the original name of this character was inspired by Bob's nickname at the studio, "Buddy."

In 1935, a newcomer named Fred "Tex" Avery persuaded Schlesinger to hire him as a studio director. Although Avery had previously worked at Walter Lantz Productions, there is no evidence that he had any experience directing. To give the new director and his unit creative isolation, they were placed in an office in the Termite Terrace building. Avery also brought two

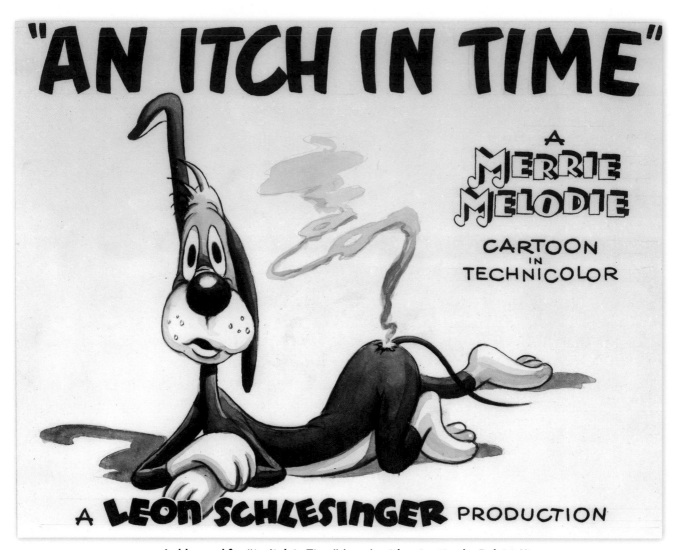

Lobby card for "An Itch in Time" (1943), with animation by Bob McKimson.

animators with him from the Lantz studio, Virgil Ross and Sid Sutherland. Other animators assigned to him were Chuck Jones and Bob Clampett for their creative ability and Bob Cannon for his draftsmanship. At a later stage, Tom, Chuck, and Bob McKimson also joined the group.

Schlesinger's gamble on Avery's ability proved to be well-founded. With the assistance of Jones and Clampett, he created a new style of animation and introduced many trends in the design of cartoon characters that helped Leon Schlesinger Productions become one of the leading cartoon studios. Although Walt Disney Productions had become the dominant cartoon studio by the mid-1930s, Schlesinger's studio had the directorial and animation muscle to challenge that superiority. To succeed, however, they would need some additional talent to raise their cartoons to new levels of excellence.

The first of those additional talents was Mel Blanc, who joined the studio and began recording voice-overs for its cartoons in 1936. Blanc, who went on to stardom not only in cartoons but also in radio and television, created the voices for all the Schlesinger/Warner Bros. major characters, with the exception of Elmer Fudd, whose voice was done by Arthur Q. Bryan. Schlesinger had been looking for a new voice for Porky Pig, the newest star in the studio's *Looney Tunes*

Animation still from "Buddy's Circus" (1934), with animation by Bob McKimson.

Buddy

Created by Tom Palmer in 1933, Buddy was the first new starting character at Leon Schlesinger Productions. The Bosko-like character would go on to star in 23 cartoons until he was retired in 1935. Buddy sings and dances frequently in the cartoons and is often accompanied by his dog, Towser, or his girlfriend, a flapper named Cookie.

Animation still from "Buddy's Day Out" (1933).

series, when Treg Brown persuaded him to interview Blanc. A lasting impression of Blanc's ability was made when he voiced the stuttering pig; in 1941, he signed an exclusive contract with Schlesinger that restricted him from doing voice-overs for other cartoon studios.

My father remembered Blanc as having a "leather larynx" and a good ear. Once a director told him what type of voice was needed for a new character, he could quickly provide the desired sounds. The first few times he voiced Bugs Bunny eating a carrot, Blanc found it difficult to say his lines clearly with pieces of carrot in his mouth. He tried using other fruits and vegetables, including apples and celery, but none produced the desired "carrot" sound. Blanc soon developed a system, munching on carrots to record the sounds and then spitting them out before recording the rabbit's next line.

The *Looney Tunes* character with a voice closest to Blanc's was Sylvester, minus the cat's slobbery lisp. Many people will remember Blanc not only as the voice of Bugs Bunny and the other *Looney Tunes* characters, but also for working with Jack Benny on his radio and television shows in later years.

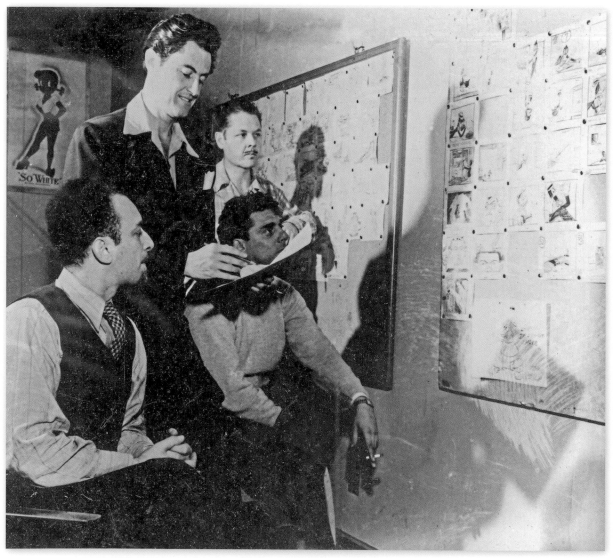

Bob Clampett (standing, left), Tom McKimson (standing, right), and staff review the storyboard for "The Great Piggy Bank Robbery," 1945.

"I Say, I Say . . . Son!"

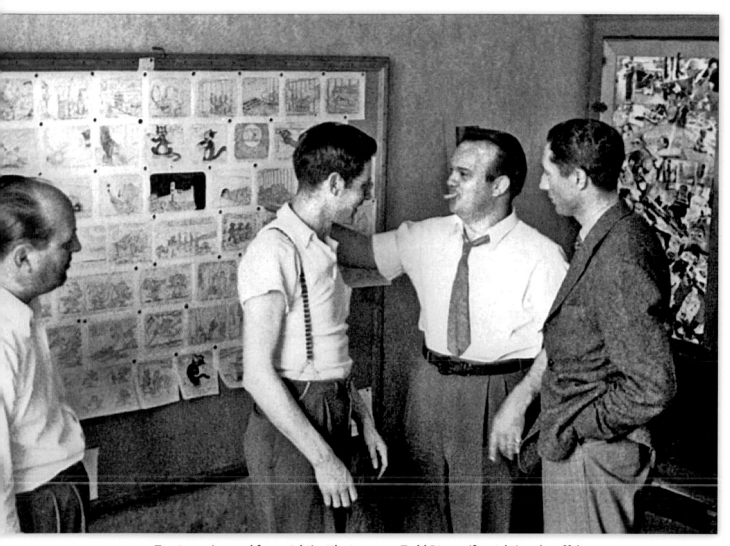

Tex Avery (second from right) with story man Tedd Pierce (far right) and staff, late 1930s.

Another great talent, composer Carl Stalling, joined Leon Schlesinger Productions in 1936. Stalling went on to compose scores for several hundred cartoons and also conducted the Warner Bros. orchestra when it recorded music tracks. Stalling's music added vitality and atmosphere in order to complement the images on the screen.

Also joining the studio in 1936 was Frank "Tash" Tashlin, who replaced Jack King as a director. Tashlin left two years later and then signed back on with the company in 1941, only to leave again in 1944 to pursue his dream of live action direction. He was the only major animation director to develop a successful career directing live action movies.

Artists Ben Washam, Ken Harris, and Phil Monroe also joined the Schlesinger studio that year and made their mark there. Washam had been trained by Bob and was considered one of the best animators in Hollywood. They all had a flair for animation, movement, and humor that stood out above the others. Many other animators could move their characters around, but they lacked the spark and humor to move them in funny ways.

Bob was personal friends with Washam, Harris, and Monroe, and invited them to our house on many occasions. They enjoyed not only working in the cartoon industry, but also in each

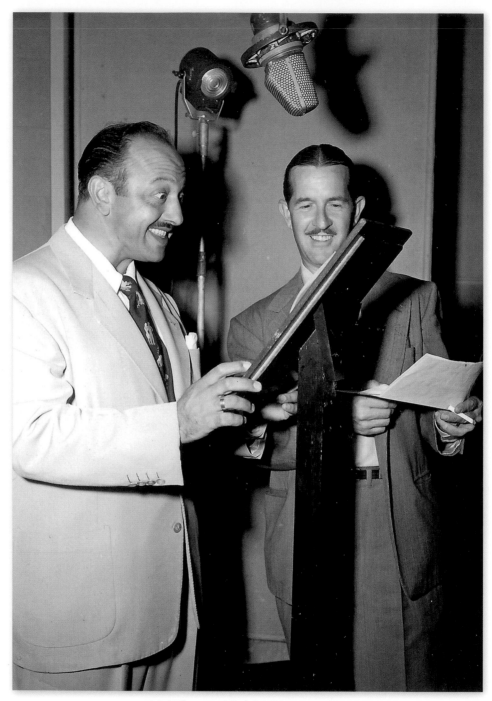

Mel Blanc and Bob McKimson, 1952.

other's company. In those days, everything was fun—that's why all of the cartoons came out funny. In the story department, the story men (one per unit) would sometimes go marching through the halls wearing different hats, coats, and other clothing while working on stories. This workplace comedy translated to the wacky cartoons seen onscreen.

My father told a story that occurred in the mid-'30s, when he parted his hair in the middle and wore a mustache. He was seated inside the El Capitan Theater (now a Disney theater) in Hollywood, and sitting next to him was the famous Hal Roach comedian Charley Chase, whom

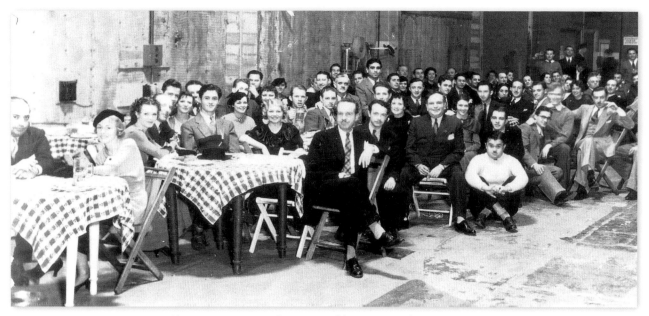

Christmas party at the Leon Schlesinger studio, 1934.

others had remarked looked exactly like my father. Evidently, the two men just sat there and looked at each other, not knowing what to say.

After Bob began his job at Leon Schlesinger Productions, for the first few years he worked mainly with directors Friz Freleng, Jack King, and Earl Duvall. He was responsible for animating some of the scenes in the first Porky Pig cartoon, "I Haven't Got a Hat," released in 1935. The

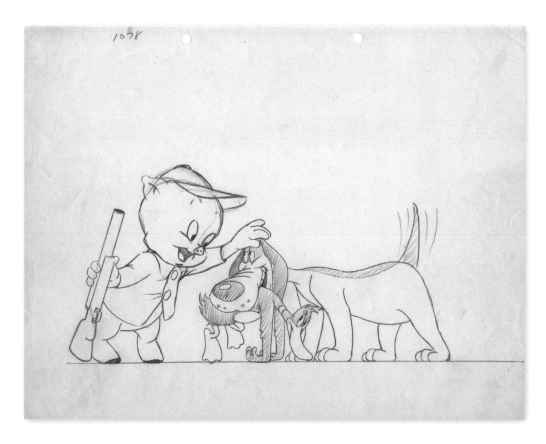

Pencil drawing for "Daffy Duck Hunt" (1949) by Bob McKimson.

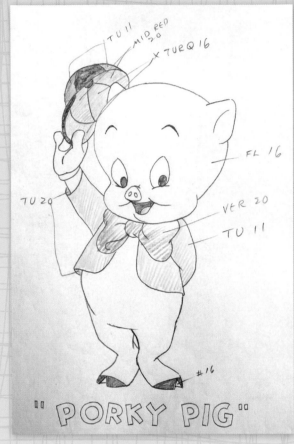

"PORKY PIG"

Above: Color model drawing by Bob McKimson.
Below: Lobby card for "One Meat Brawl" (1947), directed by Bob McKimson.

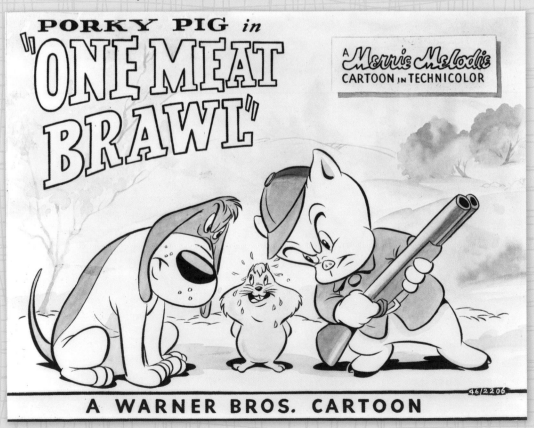

"I Say, I Say . . . Son!"

Above: Layout drawing for "Dime to Retire" (1955) by Bob McKimson.
Below: Animation still from "I Haven't Got a Hat" (1935), with animation by Bob McKimson.

Daffy Duck

Daffy first appeared in the 1937 cartoon "Porky's Duck Hunt," directed by Tex Avery. The cartoon began a series of Porky Pig and Daffy Duck pairings, with the recurring theme of Porky hunting Daffy with his trusty shotgun.

Although his coloring has remained the same over the years, Daffy originally had a short, squat body. Bob Clampett animated Daffy for "Porky's Duck Hunt," relishing the challenge of drawing the nutty duck. When Bob McKimson later took on the task of animating Daffy, Clampett asked him to create a revised model sheet for the character. The result was a taller, leaner version of Daffy.

Daffy quickly became popular with audiences, who fell in love with his wacky, conniving character. His slobbery lisp, created and vocalized by Mel Blanc, is also the voice of another Warner Bros. character—Sylvester—but recorded at a faster speed. Daffy appeared in over 125 classic *Looney Tunes* cartoons.

© WARNER BROS. PICTURES INC.

Left: **Layout drawing for "Fool Coverage" (1952), directed by Bob McKimson
with animation by Chuck McKimson.**
Right: **Animation cel.**

"I Say, I Say . . . Son!"

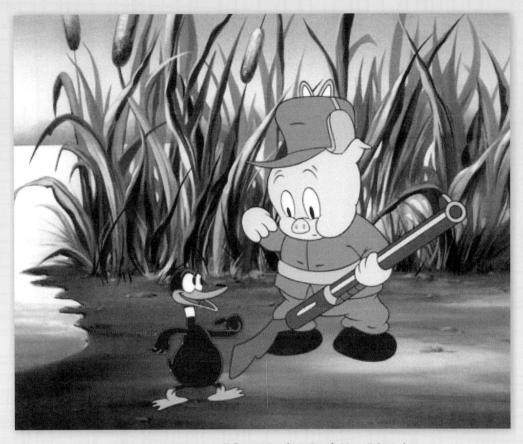

Above: Animation still from "Porky's Duck Hunt" (1937).
Below: Lobby card for "The Great Piggy Bank Robbery" (1946), with animation by Tom McKimson.

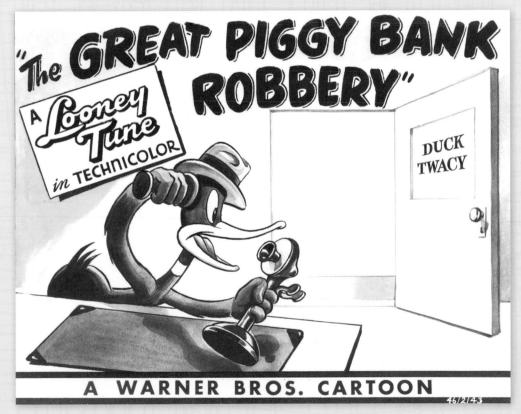

Animation still from "Daffy Duck Slept Here" (1948), directed by Bob McKimson
with animation by Chuck McKimson.

"I Say, I Say ... Son!"

Pencil drawing (above) and animation still (below) from "Daffy Duck Hunt" (1949), directed by Bob McKimson with animation by Chuck McKimson.

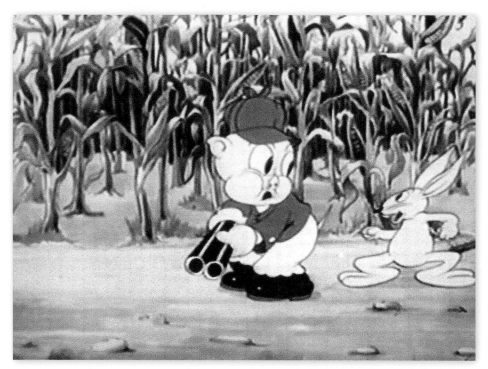

Animation still from "Porky's Hare Hunt" (1938).

In 1939, Warner Bros. created its most famous character: Bugs Bunny. Leon Schlesinger Productions story man Ben "Bugs" Hardaway, who directed a 1938 cartoon called "Porky's Hare Hunt" that features a mischievous, anonymous gray rabbit, is often given credit for the character. Bob McKimson likened this to giving someone who worked at Terrytoons Cartoon Studio credit for creating Mickey Mouse, saying that Hardaway's drawing bore a stronger resemblance to Walter Lantz's Oswald the Lucky Rabbit than to Bugs Bunny.

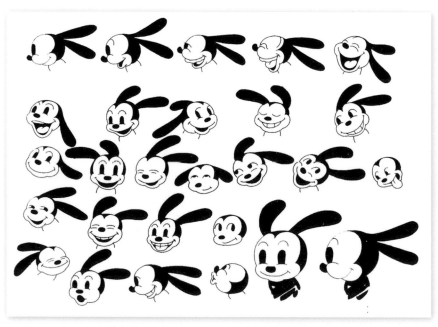

Model sheet for Oswald the Lucky Rabbit, 1928.

"I Say, I Say . . . Son!"

Many animation historians have also suggested that animator Robert Givens created the first model sheet of Bugs Bunny in 1940, and that Bob McKimson refined the rabbit's look with a 1943 model sheet that became the gold standard for Bugs cartoons. Givens's model sheet, labeled "Tex's Rabbit," was created for the Tex Avery cartoon "A Wild Hare." In a 1979 letter to Michael Barrier, Avery himself said that he hadn't used Givens's model sheet for "A Wild Hare" at all, but instead used a rough draft by Givens that Bob McKimson had refined.

"I don't give anybody any credit for creating Bugs Bunny except Tex Avery for the character, and me, for the way he looks," Bob McKimson said in a 1971 interview with Barrier. In any case, Bob played a vital role in the creation of the cartoon rabbit; on the 1944 copyright registration for Bugs Bunny, he is named as the artist.

Copyright registration for Bugs Bunny, 1944.

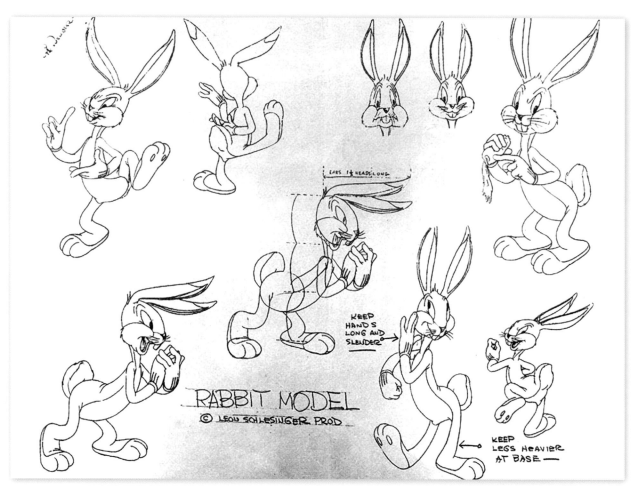

Above: Bugs Bunny model sheet by Bob McKimson, 1941.
Below: Bob McKimson reviewing a pencil test with his unit, 1952.

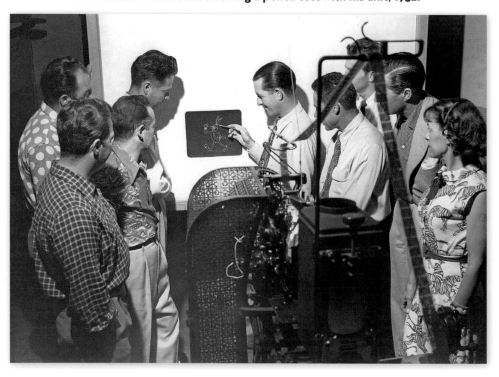

Bugs Bunny

The most famous character in the *Looney Tunes* cast was first featured in the 1940 release "A Wild Hare." Although there is some debate among animation historians over who should be credited for the creation of Bugs Bunny, Bob is listed in the Library of Congress on April 10, 1944, as the artist of a "cartoon figure named 'Bugs Bunny' designed for use as an animated character in motion picture animated cartoons."

After "A Wild Hare," Bob continued to refine the Bugs Bunny model sheet until 1943, when he drew the definitive Bugs model. Avery developed the rabbit's personality so he would behave and react to situations in the way most people would love to, if they had the nerve. Completing the characterization was the rabbit's Brooklyn/Flatbush accent, developed by Mel Blanc. Bugs went on to appear in 171 classic *Looney Tunes* cartoons.

When viewing "A Wild Hare," it should be noted that the very first thing Bugs says to his would-be assassin, Elmer Fudd, are the immortal words "What's up, Doc?" This Bugs Bunny hallmark originated in Avery's Texas high school, where it was a popular catchphrase among students.

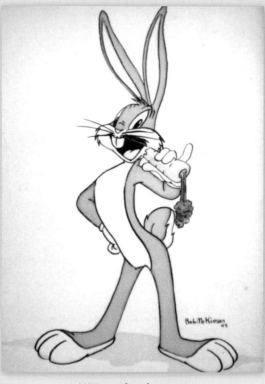

Watercolor drawing by Bob McKimson, 1943.

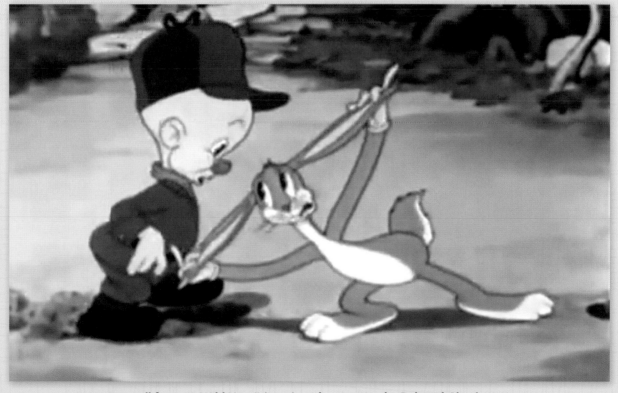

Animation still from "A Wild Hare" (1940), with animation by Bob and Chuck McKimson.

(Interestingly, my father's nickname for me when I was growing up was "Doc.") By viewing this first Bugs cartoon and the others that followed, it is possible to see how the character evolved from its first rendition through a series of model sheets, until the definitive Bugs Bunny appeared in 1943. It was at this time that Bob first drew the rabbit's most well-known pose, leaning against a tree with a carrot in his hand, for a Los Angeles department store promotion.

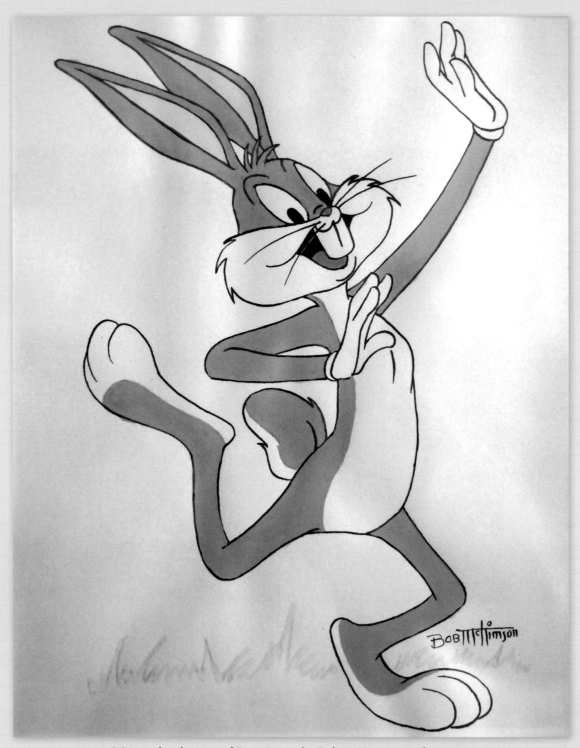

Watercolor drawing of Bugs Bunny by Bob McKimson, early 1970s.

"I Say, I Say . . . Son!"

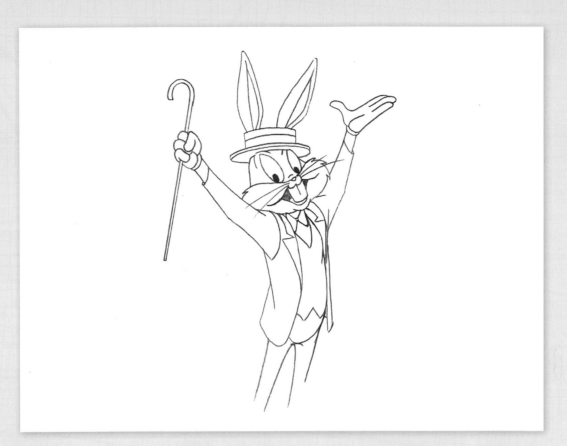

Layout drawing (above) and limited edition cel (below) from *The Bugs Bunny Show* by Bob McKimson.

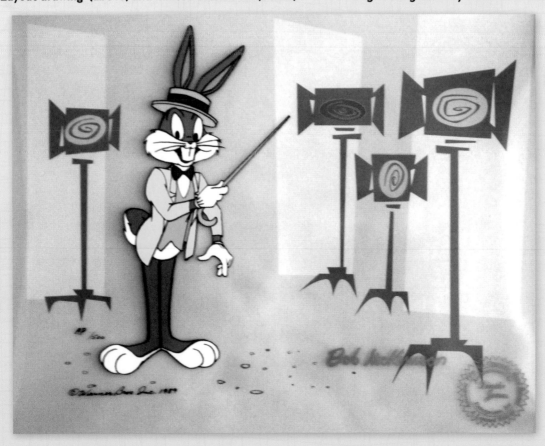

"I Say, I Say . . . Son!"

A.P. 1/15

Limited edition cel (above) and sericel (opposite) from original drawings by Bob McKimson.

Illustration drawings (above and opposite) and album cover (below) for the Capitol Record Reader
Bugs Bunny and the Tortoise, 1948.

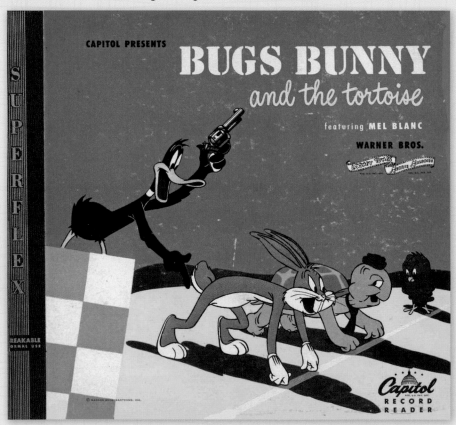

"I Say, I Say . . . Son!"

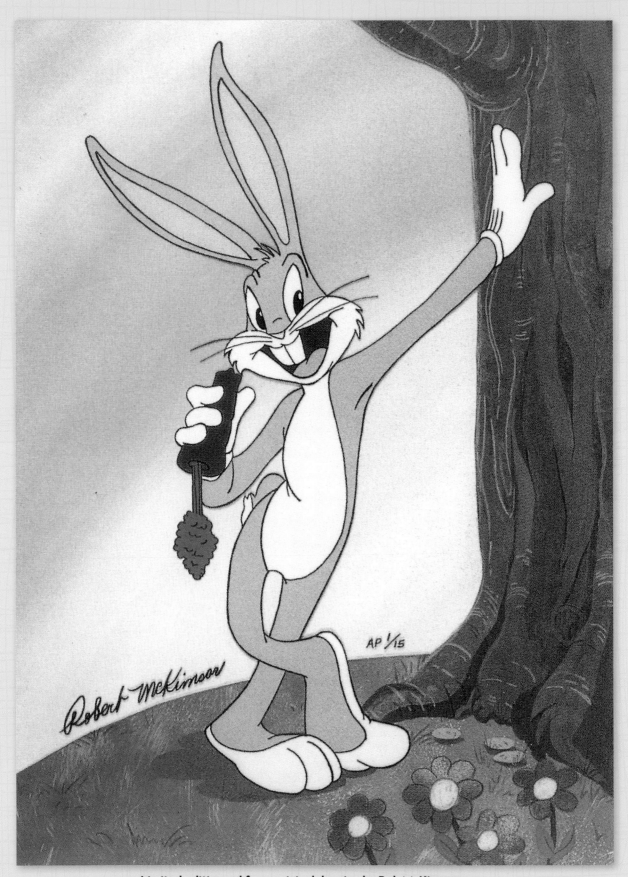

Limited edition cel from original drawing by Bob McKimson.

"I Say, I Say . . . Son!"

Above: Original lobby card drawing for "A-Lad-in His Lamp" (1948) by Bob McKimson,
drawn using Jean Blanchard's model of Bugs Bunny.
Below: A revised version of the lobby card by Hawley Pratt, drawn using the traditional Bugs Bunny model.

Overleaf: Limited edition cel from "A-Lad-in His Lamp" (1948),
directed by Bob McKimson with animation by Chuck McKimson.

Above: Lobby card drawing for "What's Up Doc?"
(1950), directed by Bob McKimson
with animation by Chuck McKimson.
Left: Animation drawing for "What's Cookin'
Doc?" (1944) by Bob McKimson.
Opposite: Limited edition cel from original
drawing by Bob McKimson.

"I Say, I Say . . . Son!"

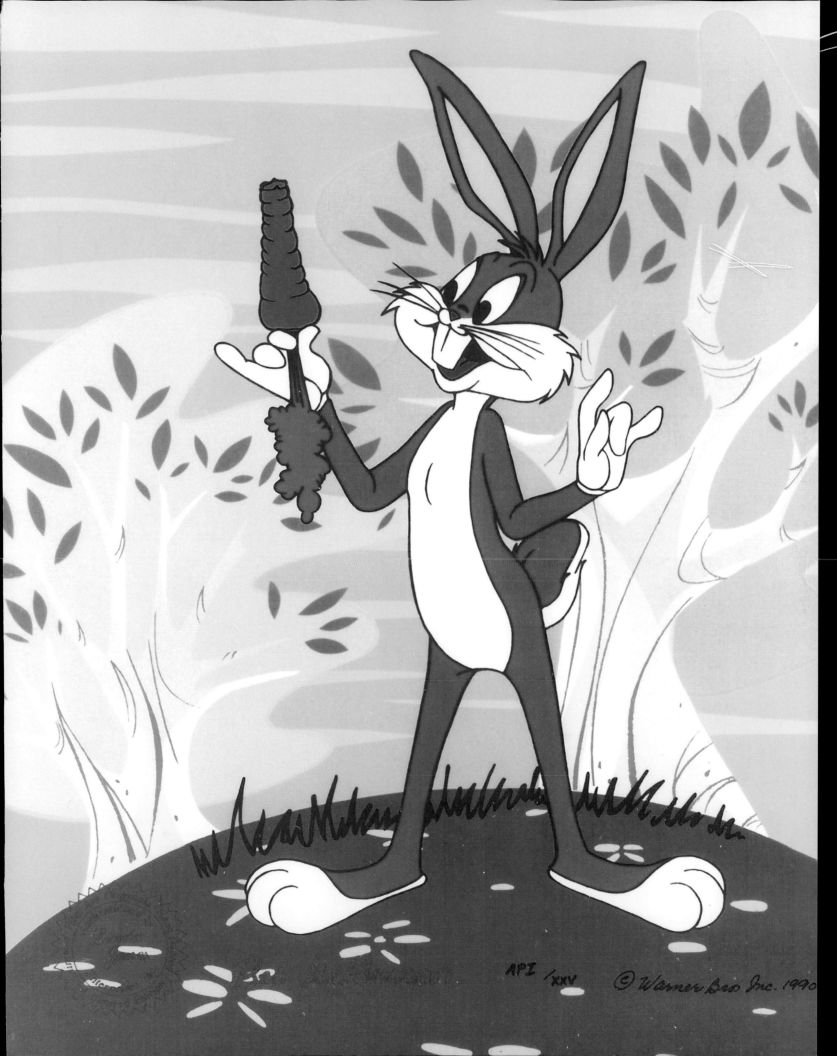

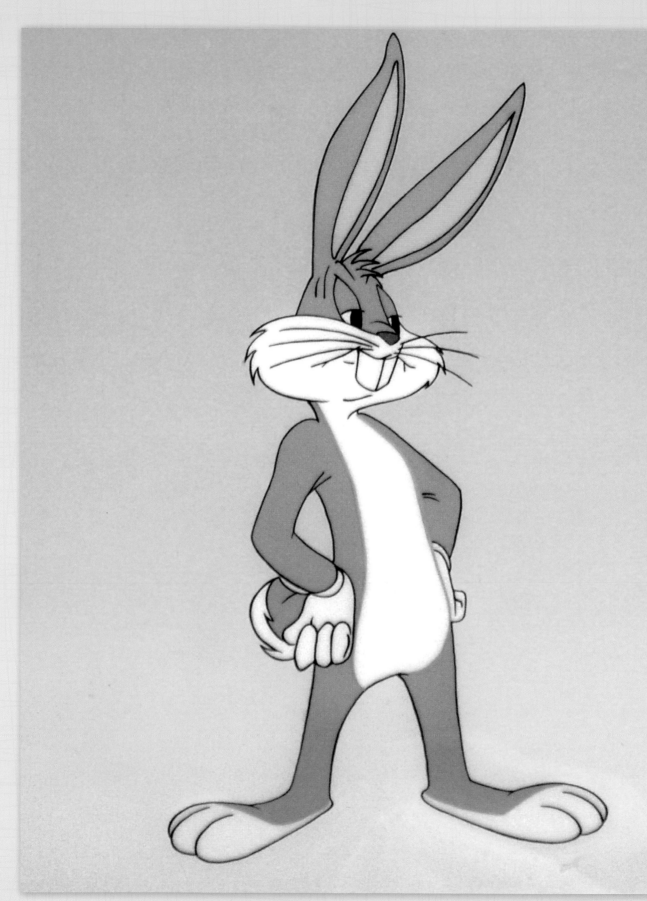

Animation cel from "Easter Yeggs" (1947), directed by Bob McKimson with animation by Chuck McKimson.

"I Say, I Say . . . Son!"

Animation drawing for "What's Cookin' Doc?" (1944) by Bob McKimson.

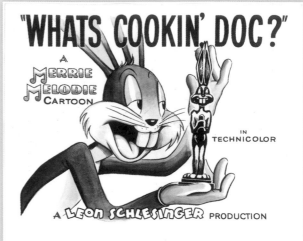

Above: Animation drawing (left) and lobby card (right) for "What's Cookin' Doc?" (1944),
with animation by Bob McKimson.
Below: Color model drawing for "Hare Ribbin'" (1944) by Bob McKimson.

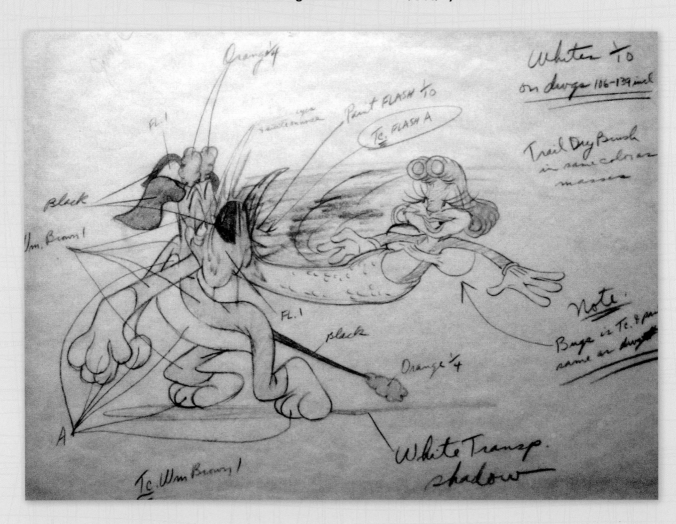

Elmer Fudd

Elmer Fudd is a cartoon creation who seemingly evolved from a character named Egghead, originally featured in Tex Avery's "Egghead Rides Again" (1937). Egghead was a wacky character with a bald head and bulbous nose who, unfortunately, failed to attract any popularity with theater audiences.

Elmer as we know him today made his debut in the Chuck Jones cartoon "Elmer's Candid Camera" (1940), with animation by Bob McKimson. The original character had certain traits in common with Egghead, including the large nose and bald head. A redesigned Elmer Fudd was introduced in Avery's "A Wild Hare," released in 1940 with animation by Bob and Chuck McKimson.

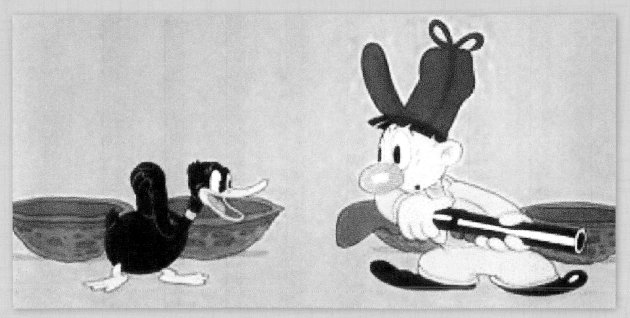

Animation still from "Daffy Duck and Egghead," 1938.

Elmer appeared in 57 classic *Looney Tunes* cartoons. In most of them, he was an unlucky hunter of "wabbits." In others, however, he would take on a personality besides the luckless hunter, but even then, Bugs Bunny would usually cross his path. Elmer, who is famous for his rhotacistic speech, was the only major *Looney Tunes* character not voiced by Mel Blanc, but rather by Arthur Q. Bryan.

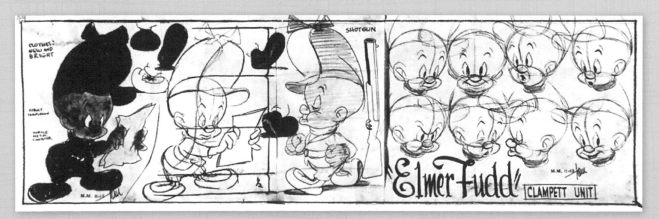

Model sheet by Tom McKimson, early 1940s.

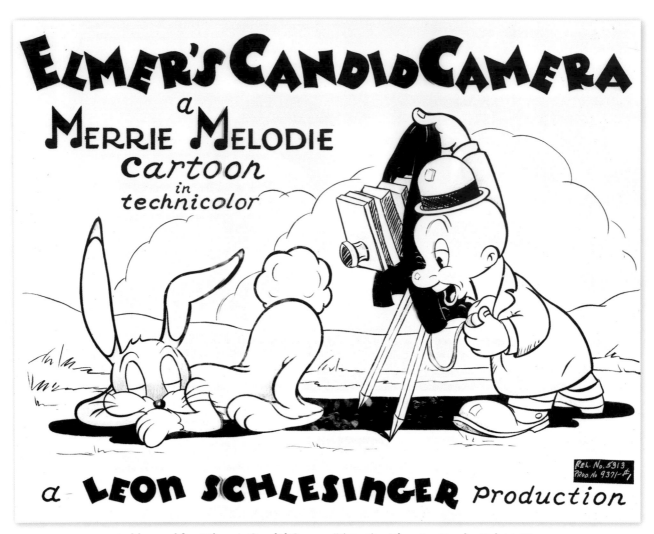

Lobby card for "Elmer's Candid Camera" (1940), with animation by Bob McKimson.

Avery did not want to make a second Bugs Bunny cartoon after "A Wild Hare," but production manager Ray Katz insisted. Avery agreed to make one for "McKimp," as he referred to Bob, knowing how he liked to animate Bugs. "Tortoise Beats Hare," released in 1941, was the second of four Bugs Bunny cartoons made by Avery. Because Avery liked his cartoons over-animated, each of these shorts was wilder than the last as Bugs's character continued to evolve.

With the advent of sound and color behind them, the Leon Schlesinger and Walt Disney studios now had the talent and inspiration to achieve greatness in animated cartoons. By 1941, the artists at the Schlesinger studio had mastered the drawing and movement skills needed to support the expanded visions they had for their cartoons. In addition, Mel Blanc had refined his voice artistry and Carl Stalling's music had grown more crisp and vigorous. All in all, the Warner Bros. cartoons had grown even funnier and were better in quality than they had been before. In the next two decades, some of the greatest achievements in cartooning would be accomplished and great animation talents would emerge and leave their mark on motion picture history for all time.

In 1933, Bob had married Viola Feley, and in 1936, Tom had married Ernestine Lackey. Both couples had settled down in West Los Angeles, and by 1940, Bob, Chuck, and Tom were all animating for Avery. At the time, there were four animation units headed by directors Avery, Friz

Freleng, Chuck Jones, and Bob Clampett. Each unit consisted of about four animators, three assistants, a story man, a layout man, and a background artist, and would put out about 10 cartoons per year, or one every five weeks.

The running time for an average cartoon was six to seven minutes. At the time, the cartoons had full animation, with 24 frames per second and about 10,000 frames per cartoon. Each cartoon incorporated about 5,000 original pencil drawings, making them very labor-intensive. The cost per cartoon ranged from $25,000 to $30,000, which was a bargain for what was achieved, even during those years. From inception to completion, the time frame to create one cartoon was about 14 months.

The process began with the story man or director coming up with a general idea and creating a storyboard with a sketch artist. Next, the director reviewed the storyboards and either added more gags or took out some of the existing ones. The storyboard was then taken to a "jam session," during which all the story men and directors helped finalize the script. Once the voice-overs had been recorded, every spoken word was handwritten on the exposure sheets to help animators match each frame to the dialogue. After a layout artist staged the ac-

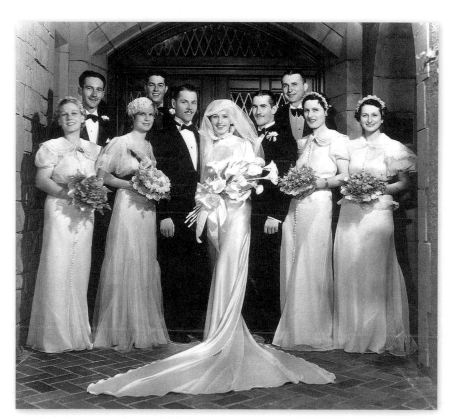

Wedding portrait of Tom (fifth from left) and Ernestine (fifth from right) McKimson and their bridal party, including Chuck (fourth from left), Bob (fourth from right), and Viola (second from right) McKimson, 1936.

tion, the director timed the cartoon frame by frame and assigned the scenes to his animators.

Once the pencil sketches were finalized and approved by the director, they went to the inkers, who placed cels (sheets of clear plastic) on a lighted board over the pencil sketches and traced the drawings with India ink. The inked cels were then turned over so the painters could fill in the characters with the appropriate colors. In the meantime, the background artist, using the layout man's models of the various scenes, made a painting of each scene's background. At that point, an overhead stop-motion camera was used to shoot the cels, which were placed one by one on top of the appropriate painted background. The background could be moved to create the illusion of camera motion. In the meantime, the voice-overs were recorded and added, as well as the musical score and sound effects. After some final editing work, a completed Warner Bros. cartoon was born.

Tex Avery's departure from Leon Schlesinger Productions in 1941 sparked a directorial musical chairs at the studio: Bob Clampett took over Avery's unit; Norm McCabe took over

Bob and Viola McKimson, mid-1930s.

Clampett's unit; and Frank Tashlin soon rejoined the studio and took over for McCabe, who had gone into the armed forces. Bob and Tom were now part of Bob Clampett's unit. Meanwhile, Chuck had gone into the U.S. Army Signal Corps, where he would work on training films for the duration of World War II.

My father remembered clearly that Clampett helped establish some very important characters at Warner Bros., such as Tweety and Daffy. You could almost tell from the characters themselves whether Clampett had had anything to do with them. Clampett had a unique and wacky sense of humor, which was a great asset when working with cartoon characters. Apparently, he would do things that Schlesinger would tell him

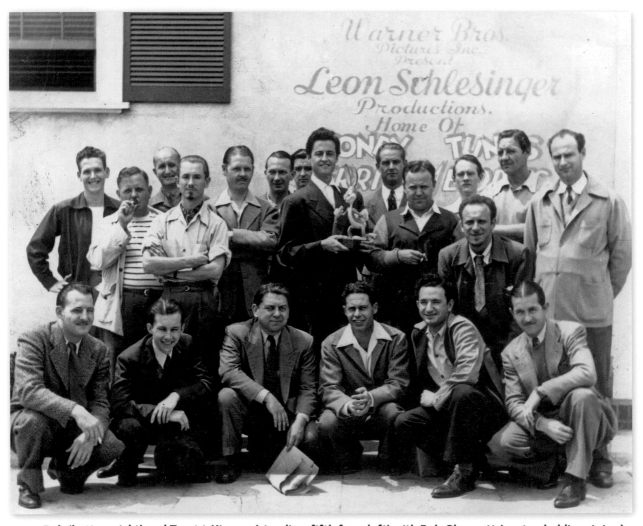

Bob (bottom right) and Tom McKimson (standing, fifth from left) with Bob Clampett (center, holding statue) and other Leon Schlesinger Studio employees, early 1940s.

"I Say, I Say . . . Son!"

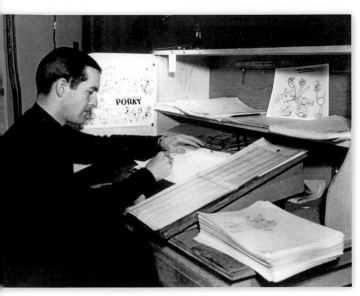

Bob McKimson at his animation desk, late 1930s.

he couldn't do, and the two were at swords' point with each other quite a bit; but Clampett somehow always managed to avoid confrontations with his boss. Schlesinger would call him into his office and get ready to bawl him out and Clampett would say, "Wait a minute, I'll be right back, I've got to go to the gentlemen's room." He would then leave and never come back. Two or so days later, Schlesinger would meet him in the hall and say, "Where the heck did you go?" Clampett would say, "What do you mean?" He would always do things that you just couldn't believe.

My father always liked Bob Clampett and thought he had a pixie sense of humor. After Clampett left the studio in 1946 and started working on the *Time for Beany* television series in 1949, he asked my father to come with him and help him with the show. Bob was tempted by the offer and thought very hard about leaving the studio, but in the end decided to stay at Warner Bros.

When Clampett created Tweety for the bird's first cartoon, "A Tale of Two Kitties" (1942), he asked Tom to draw the model sheets for the character. The three original Tweety cartoons drawn by Clampett featured a pink bird that was completely devoid of feathers. However, due to censorship that would not allow a "nude" bird to appear in cartoons, Tweety ended up being "covered up" with yellow feathers. Tweety made his feathered debut in the 1947 release "Tweetie Pie," directed by Friz Freleng. Tom also drew the model sheet for another new character, Beaky Buzzard, who starred with Bugs Bunny in "Bugs Bunny Gets the Boid," released in 1942 and directed by Clampett.

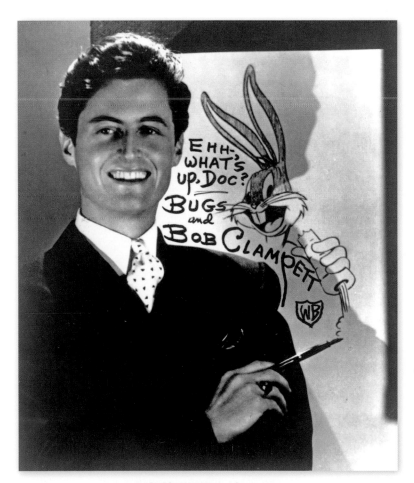

Bob Clampett, early 1940s.

Tweety

Created by director Bob Clampett, Tweety was first introduced in the 1942 cartoon "A Tale of Two Kitties," which featured animation by Tom and Bob McKimson. Clampett's original version of Tweety was featherless, a design feature that conflicted with censorship rules regarding nudity. When Clampett left the studio in 1946, director Friz Freleng took over the Tweety character and added yellow feathers to the tiny bird. In 1950, Tweety's famous line, "I tawt I taw a puddy tat," was made into a song sung by Mel Blanc; unfortunately, the tune was never used in any of the cartoons.

Tweety was often paired with the character Sylvester. Enclosed securely in his cage, the lovable baby canary always seemed to outsmart the devious alley cat. Tweety appeared in 46 classic *Looney Tunes* cartoons.

Drawing by Bob McKimson, circa 1950s.

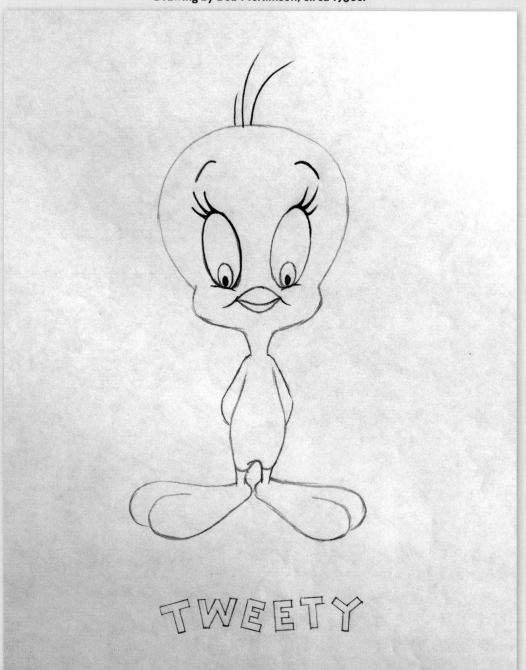

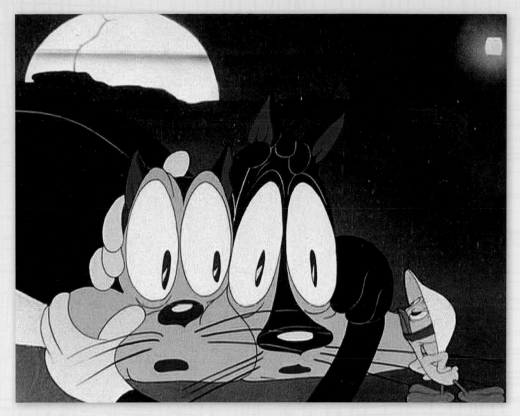

Above: Animation still from "A Tale of Two Kitties" (1942), with animation by Bob McKimson.
Below: Model sheet by Tom McKimson, 1944.

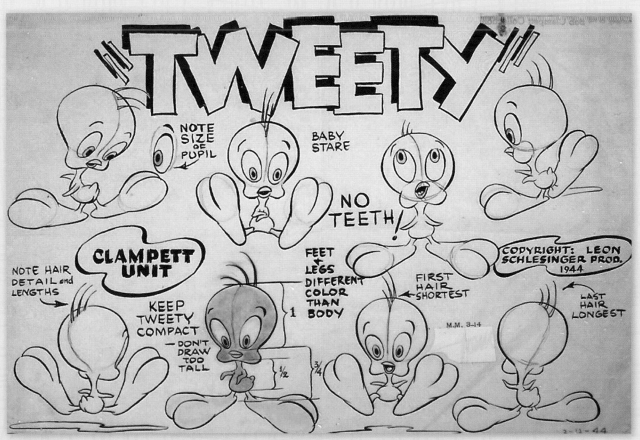

By this time, World War II was well underway, and much of the animation talent had joined the armed forces. Chuck would spend most of the war period in New York City doing training films for the U.S. Army Signal Corps, which he had joined in 1941. During the war, Bob, Tom, and many others remained at the Schlesinger studio, doing not only cartoons but also special projects related to the war effort. My father remembered drawing over 150 Bugs Bunny insignias during the war for different branches of the military. Bugs was especially popular at this time, embodying the cocky humor of a nation that had survived an economic crisis and was now facing a terrible war.

Bugs's likeness was contributed by the studio to various areas of the armed forces as part of the war effort. This included nose art on bombers and on the hospital ship USS *Comfort*. An image of Bugs Bunny holding an uneaten carrot was painted on the lead Liberator bomber that made the first attack on a Philippine city, which prompted the Allies' march back to the Philippines. Bugs Bunny was actually given a service record by the Marine Corps.

It is difficult now to comprehend the tremendous emotional impact Bugs Bunny had on those movie theater audiences, who had seen the enemy wreak havoc and threaten their existence. It was during these war years that Leon Schlesinger Productions surpassed Disney and MGM for the first time to become the number-one short subject cartoon studio. Theater owners specifically named Bugs Bunny as the character that was perking up their attendance figures. During the war, the Schlesinger studio received countless requests for drawings of Bugs. I can remember, as a young boy, asking my father about Bugs and believing that he was a real, live person. My father claimed that Bugs was indeed a real person and that he lived at the studio.

In addition to its usual cartoons, the Schlesinger studio produced several special projects related to the war. In 1942, Clampett directed a short feature, with animation by Bob and Tom, that served as a fundraiser. In this animated short, Bugs Bunny dances and sings to an Irving Berlin song called "Any Bonds Today?" It ends with Bugs dressed as Uncle Sam, doing an Al Jolson impersonation along with Porky Pig and Elmer Fudd.

From 1943 to 1945, the studio produced a total of 24 cartoons featuring a new character named Private Snafu. These cartoons, which were

Bugs Bunny nose art on a World War II airplane.

actually instructional films that featured Snafu committing blunders or infractions, were shown exclusively to members of the armed forces. The studio also produced similar animated films featuring the Navy version of Snafu, who was named Seaman Hook. All of the storyboards for Snafu and Hook had to be approved by the Pentagon. In order to appeal to the soldiers and sailors, the films tended to be a bit risqué and included several "cheesecake" shots.

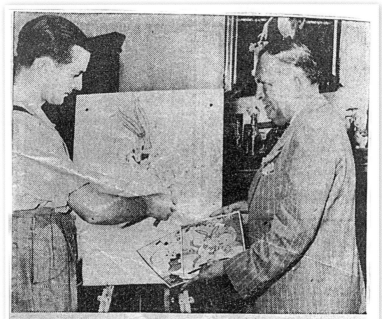

BOND BOOSTER—Bugs Bunny cartoons are being displayed by Robert McKimson, animator, to Leon Schlesinger, whose artists are producing cartoons that will be given to high war bond bidders at Beverly-Fairfax Victory House Thursday from 2 to 4 p.m. There will be special drawings for youngsters buying bonds and stamps.

Above and below: **Newspaper articles to sell bonds, early 1940s.**

THEY'RE IN THE SERVICE NOW... SELLING BONDS - AND HOW!

Leon Schlesinger contributed to the Defense Savings Drive a special Technicolor cartoon in which Bugs Bunny sings "Any Bonds Today?"

The Big Bad Nazi Wolf is defied by The Thrifty Pig in a Walt Disney Technicolor picture made for the Canadian Defense Savings Bond Campaign.

Private Snafu

Created by film director Frank Capra, Private Snafu was the lead character in a series of black-and-white U.S. Army instructional cartoons (some written by Theodor "Dr. Seuss" Geisel) produced between 1943 and 1945. Leon Schlesinger Productions outbid the Disney studio for the production contract and also got ownership of the character and merchandising rights.

Private Snafu appeared in a total of 24 cartoon shorts. For the most part, these shorts were educational; however, the animation directors were given a lot freedom to make the cartoons entertaining for the troops. After the end of World War II, Snafu and his cartoons were largely forgotten.

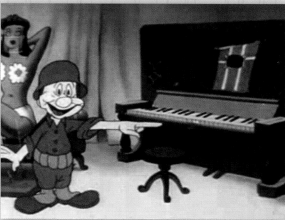

Above and right: **Animation stills from "Booby Traps" (1944), with animation by Bob McKimson.**
Below: **Model sheet for Private Snafu, early 1940s.**

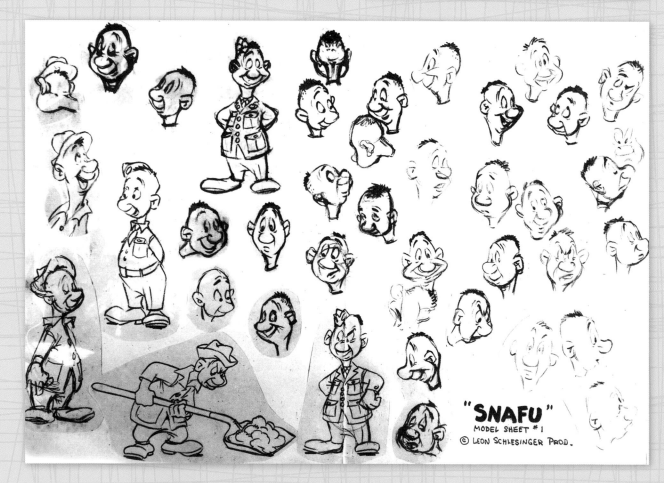

"SNAFU"
MODEL SHEET #1
© LEON SCHLESINGER PROD.

"I Say, I Say . . . Son!"

Seaman Hook

Seaman Hook was the creation of Hank Ketcham (creator of the *Dennis the Menace* comic strip), who also wrote the four Hook cartoons made for the U.S. Navy during World War II. The shorts were produced to encourage the enlisted sailors to save money. Hook was first featured in a 1943 Walter Lantz Productions short called "Take Heed Mr. Tojo."

The three remaining Hook shorts were made by Warner Bros. Cartoons and released in 1945. The final Hook short, "The Return of Mr. Hook," was directed by Bob McKimson and featured voice-overs by Mel Blanc and Arthur Lake (Dagwood Bumstead of radio and film fame).

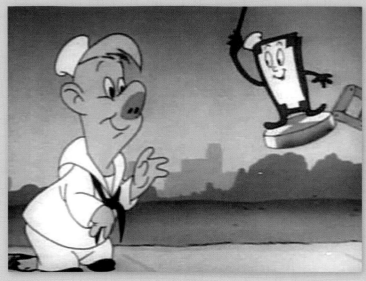

Animation still from "Tokyo Woes" (1945), with animation by Bob McKimson.

Model sheet for Seaman Hook.

Watercolor drawing by Bob McKimson, early 1970s.

Chapter Five
Warner Bros. Cartoons
1944-1963

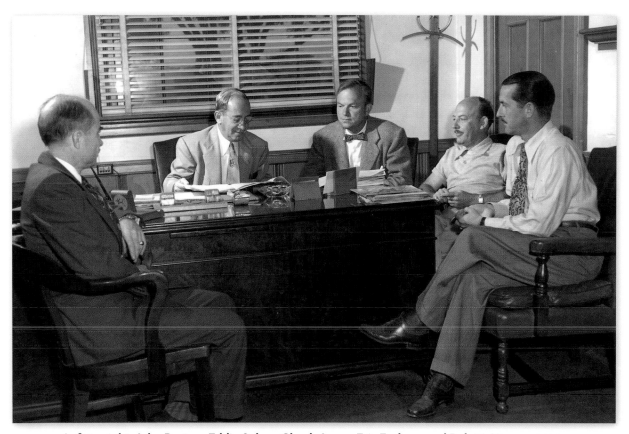

Left to right: John Burton, Eddie Selzer, Chuck Jones, Friz Freleng, and Bob McKimson, 1952.

In 1944, Leon Schlesinger sold his studio to Warner Bros., and it became Warner Bros. Cartoons. Warner installed Edward "Eddie" Selzer—who had first been its West Coast director of publicity, then the head of its trailer and title department—as the head of the studio. It is said that Selzer was born devoid of a sense of humor, and that Jack Warner wanted to get him off the main lot because of this. Apparently, Selzer had tried to get into the story area, which he didn't know anything about, and the directors had to come up with ways to keep him out of it. Selzer, who thought that if you weren't at your desk drawing, you were loafing, was in the studio one day and heard laughing down the hall. He went into the story room and asked why they were laughing. "Do you think this is a country club?" he demanded. He could not understand why anybody would laugh at work, even in a cartoon studio.

In 1944, director Frank Tashlin took a job at Paramount, leaving his position at Warner wide open. Bob went to Selzer's office and asked if Tash was leaving the studio. When Selzer said yes, Bob replied, "It's about time I took over."

Drawing by Bob McKimson.

"I Say, I Say . . . Son!"

Yosemite Sam

A short-tempered, redheaded cowboy who detests rabbits, Yosemite Sam is constantly hunting Bugs Bunny. The character, created by Friz Freleng and Mike Maltese, first appeared in "Hare Trigger," released in 1945. Freleng and Maltese were seeking a stronger, more formidable character than Elmer Fudd to serve as Bugs Bunny's archenemy. In the end, however, Yosemite Sam does not prove to be much brighter than Elmer. Although he is known to be based on the Sheriff Deadeye character from *The Red Skelton Show*, it is said that the fiery cowboy was also patterned on Freleng, who had a rather volatile temper himself.

Yosemite Sam was featured in 33 classic *Looney Tunes* cartoons.

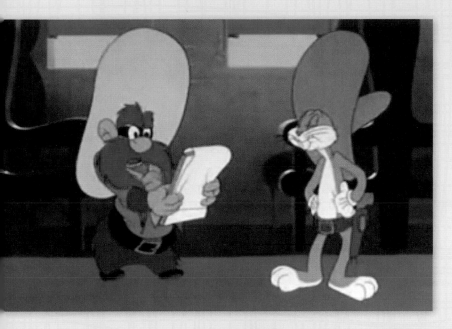

Left: Animation still from "Hare Trigger" (1945).
Below: Limited edition sericel from drawing by Bob McKimson.

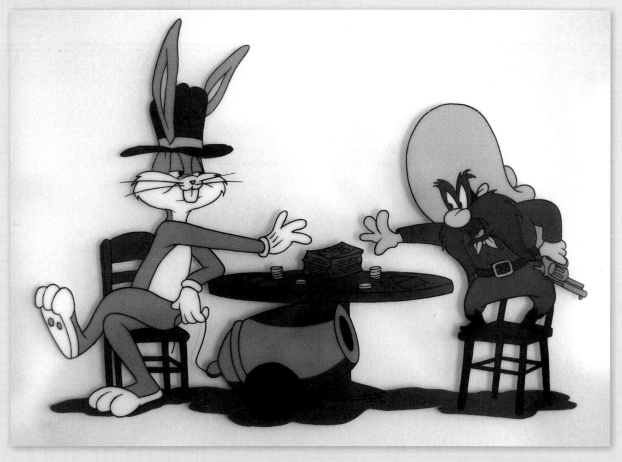

Freleng also developed the character Sylvester, a cat with a sloppy lisp who first appeared in the 1945 release "Life with Feathers." Voiced by Mel Blanc, the black-and-white cat went on to be paired with Tweety, Sylvester Jr., Hippity Hopper, Foghorn Leghorn, and Speedy Gonzales.

When Bob was promoted from animator to director, he didn't find the transition to be very difficult; in fact, he didn't think there was much of a transition at all, since he had already worked closely with director Bob Clampett and had done practically everything the position required.

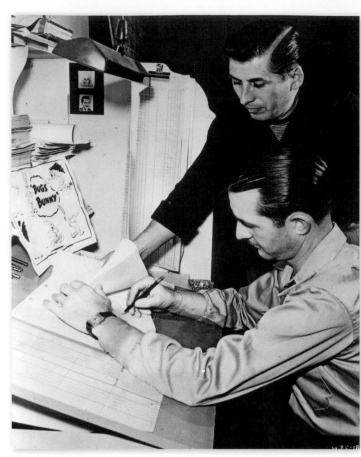

Right: **Bob McKimson (seated) with animator Richard Bickenbach, 1945.** *Below:* **Animation cel.**

"I Say, I Say . . . Son!"

Sylvester

Sylvester is a black-and-white cat with a lisp whose first appearance was in the Oscar-nominated "Life with Feathers" (1945), directed by Friz Freleng. Audiences first saw the famous pairing of Sylvester and Tweety in the 1947 release "Tweetie Pie," also directed by Freleng. This short won the Academy Award that year for Best Short Subject in the Cartoons category. Sylvester also appeared with his innocent but wise son, Sylvester Jr., as well as Foghorn Leghorn, Elmer Fudd, and Hippety Hopper.

Usually the fall guy in cartoons, Sylvester often thinks he is in control of the situations he finds himself in, but ends up being outwitted by his opponents every time. The slobbery cat appeared in nearly 100 classic *Looney Tunes* cartoons.

Above: Lobby card for "Claws In the Lease" (1963), directed by Bob McKimson.
Right: Lobby card for "Cat's Paw" (1959), directed by Bob McKimson.
Below: Animation drawing.

Above: Drawing for a TV commercial by Bob McKimson, circa 1960s.
Below: Animation drawing for "Hop, Look and Listen" (1948) by Bob McKimson.

Above and below: Layout drawings for "Lighthouse Mouse" (1955) by Bob McKimson.

Above: Lobby card for "The Foghorn Leghorn" (1948), directed by Bob McKimson with animation by Chuck McKimson.
Below: Limited edition cel from "Walky Talky Hawky" (1946), directed by Bob McKimson.

Above: Layout drawing for "Of Rice and Hen" (1953) by Bob McKimson.
Below: Model drawing of Barnyard Dawg for "Walky Talky Hawky" (1946), directed by Bob McKimson.

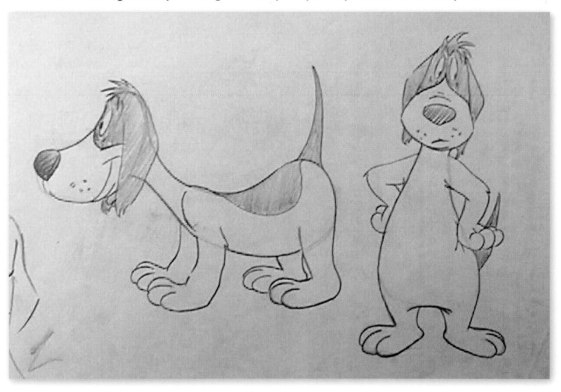

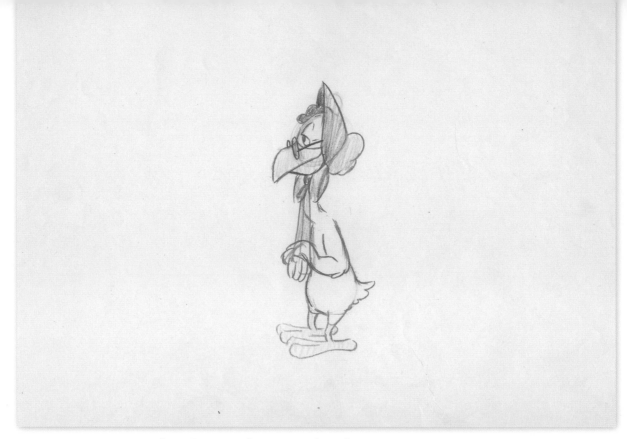

Above: Drawing of Miss Prissy by Bob McKimson, circa 1950s.
Below: Animation still from "A Broken Leghorn" (1959), directed by Bob McKimson.
Opposite: Watercolor drawing of Miss Prissy by Chuck McKimson, early 1990s.

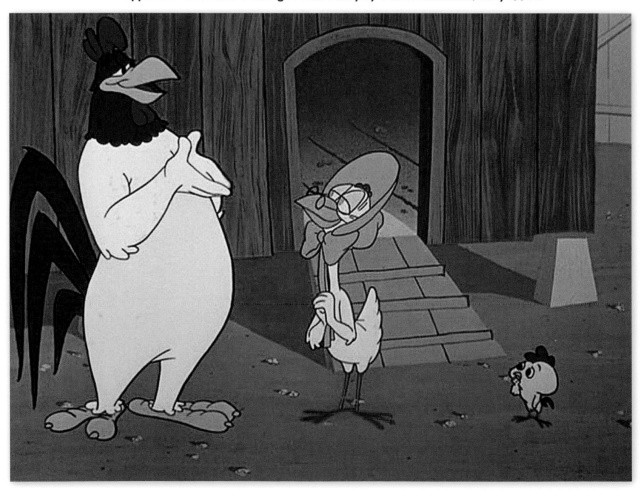

"I Say, I Say . . . Son!"

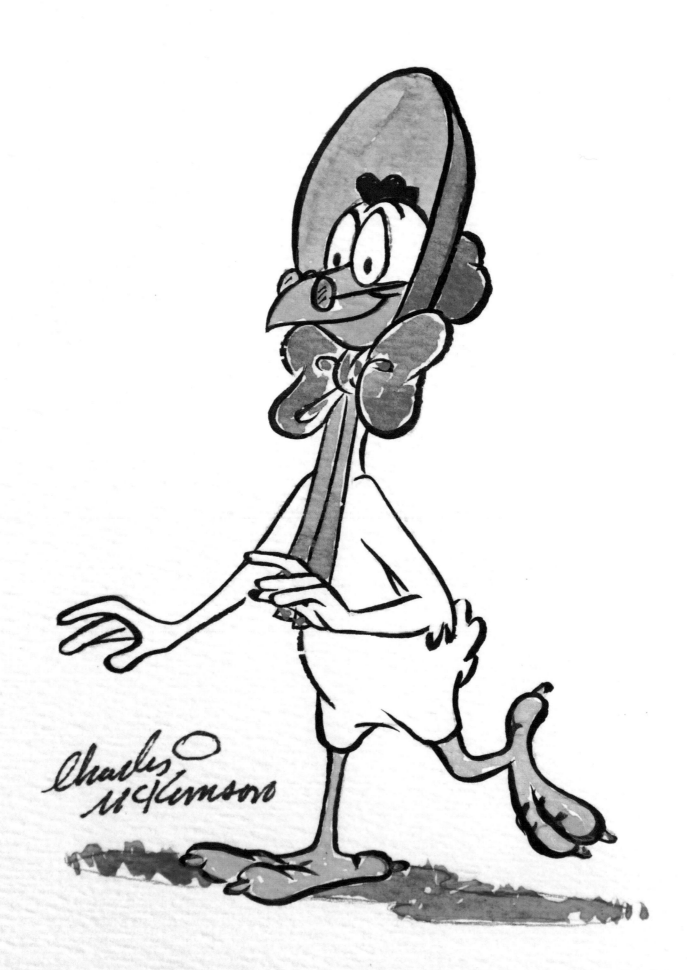

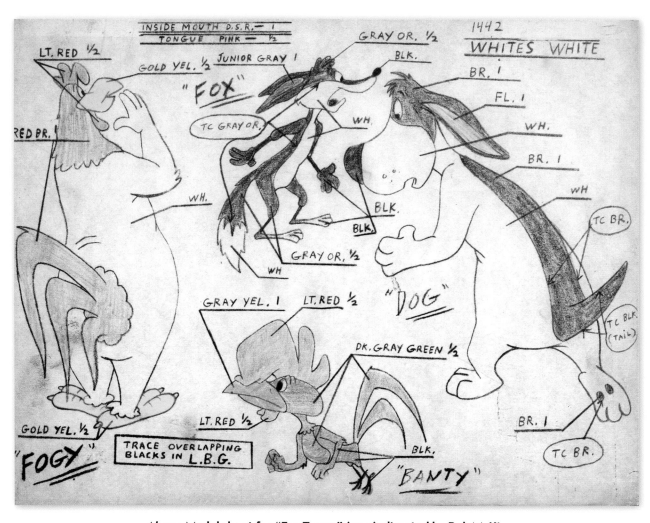

Above: Model sheet for "Fox-Terror" (1957), directed by Bob McKimson.
Below: Layout drawing for "Hen House Henery" (1949), directed by Bob McKimson
with animation by Chuck McKimson.

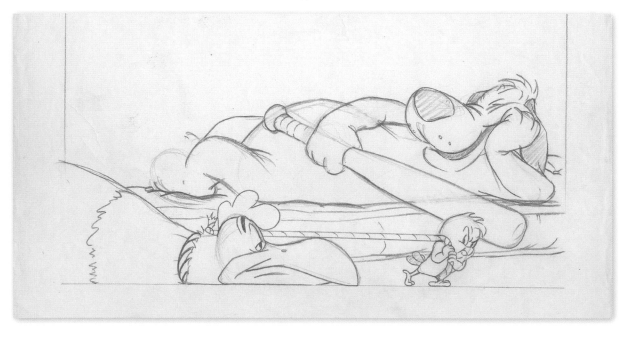

Foghorn Leghorn

The first Warner Bros. character created solely by Bob McKimson, Foghorn Leghorn, who was voiced by Mel Blanc, made his debut in the Academy Award-nominated 1946 cartoon "Walky Talky Hawky." A tall, mouthy Leghorn rooster with a Southern drawl, Foghorn is one of the two most famous characters created by Bob (the other being the Tasmanian Devil).

The big rooster was initially featured with Henery Hawk and Barnyard Dawg, who is Foghorn's constant target. One of the rooster's ongoing gags was provoking Barnyard Dawg until he chased him, which ended up choking the poor pooch when his leash reached its limit. Foghorn appeared in 29 classic *Looney Tunes* cartoons.

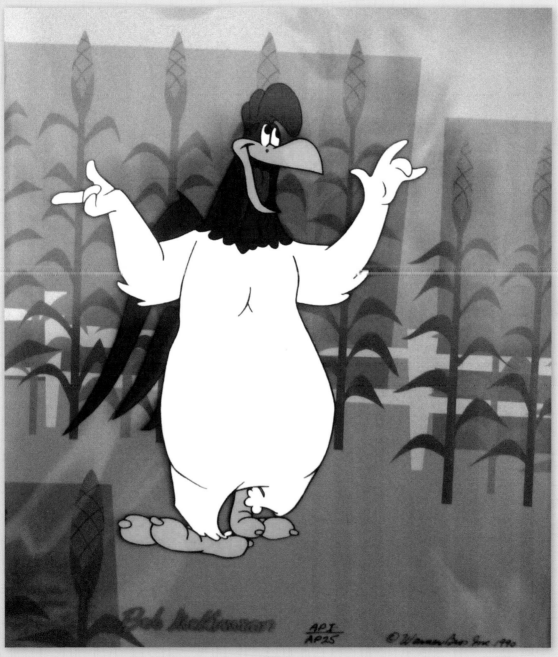

Limited edition cel from original drawing by Bob McKimson.

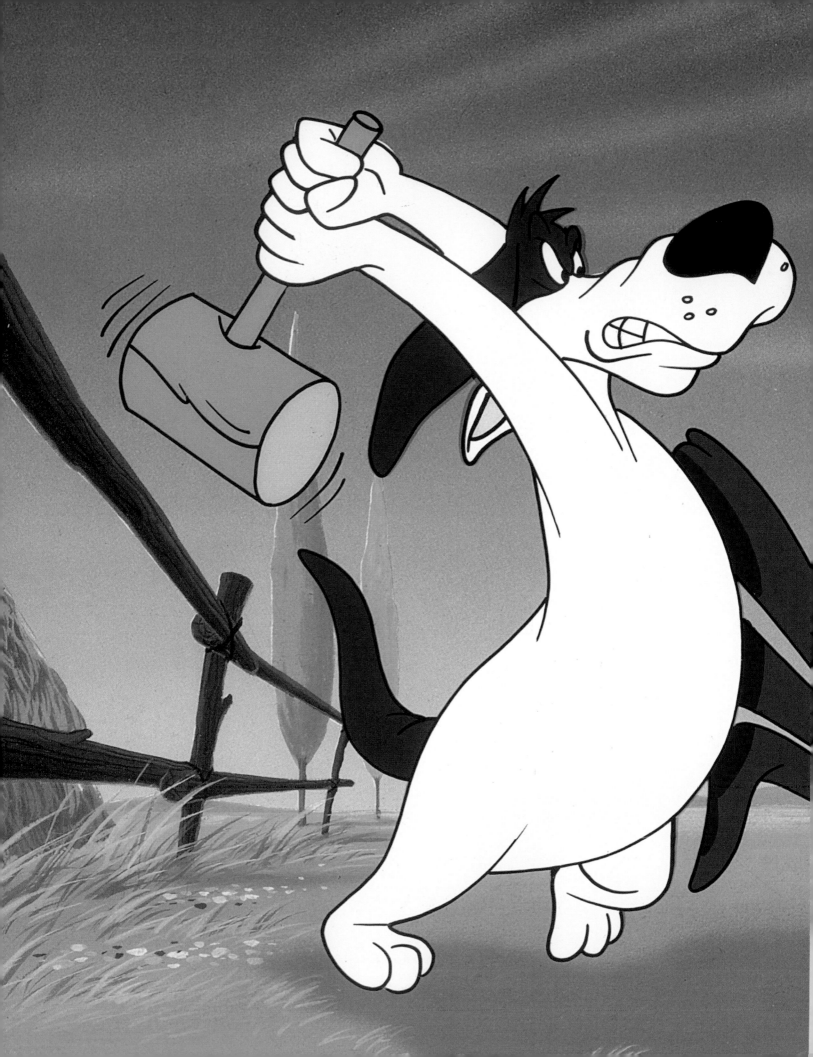

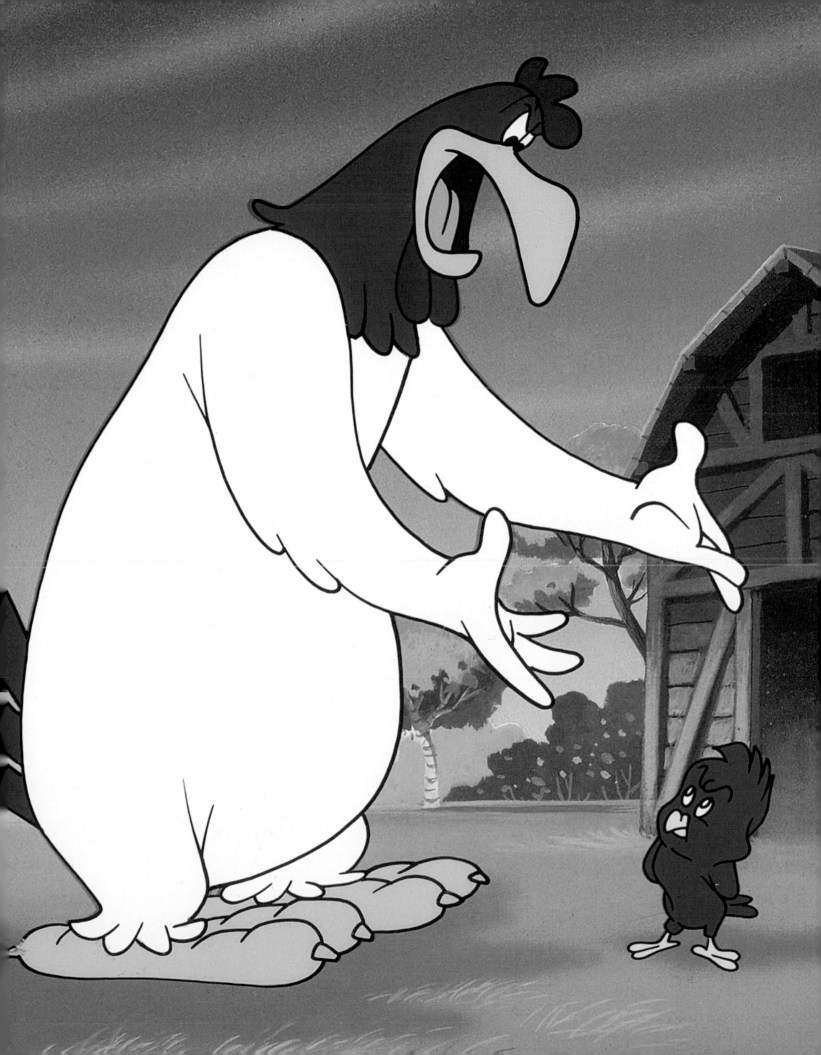

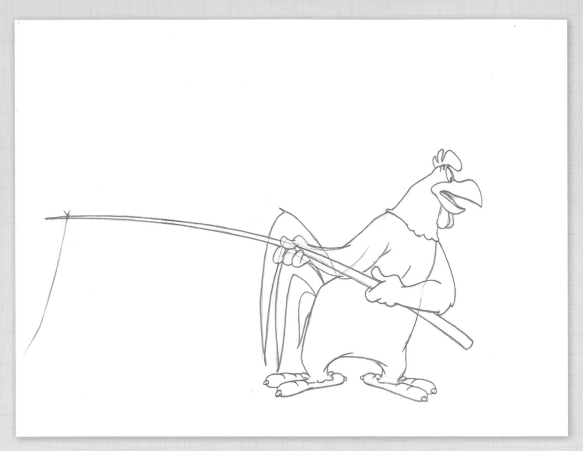

Above: Layout drawing by Bob McKimson.
Below: Lobby card for "Feather Bluster" (1958), directed by Bob McKimson.

"I Say, I Say . . . Son!"

Henery Hawk

Henery is a tough, young chicken hawk with a New York accent who first appeared in "The Squawkin' Hawk" (1942), directed by Chuck Jones. The little chicken hawk wasn't used again until Bob McKimson featured him in his first Foghorn Leghorn cartoon, "Walky Talky Hawky" (1946). Although he doesn't know what a chicken is, Henery is constantly hunting them, having been told by his father that all chicken hawks should hunt and eat chickens. Henery starred in 12 classic *Looney Tunes* cartoons.

Above: Lobby card for "The Foghorn Leghorn" (1948), directed by Bob McKimson with animation by Chuck McKimson.
Below: Drawing by Bob McKimson, circa 1950s.

HENERY HAWK

Above: Lobby card drawing for "The Egg-cited Rooster" (1952) by Bob McKimson.
Below left: Publicity drawing by Bob McKimson.
Below right: Production cel from "The Egg-cited Rooster" (1952), directed by Bob McKimson.

"HENERY HAWK"

"I Say, I Say . . . Son!"

The creation of Foghorn Leghorn began when Bob's story man, Warren Foster, had an idea for a cartoon featuring a rooster. Bob brought up a popular character called Senator Claghorn that he had recently heard on the radio program *The Fred Allen Show*. Kenny Delmar, the actor who played Claghorn, had taken his voice delivery from a sheriff character on *Blue Monday Jamboree*, an older radio program. The old sheriff repeatedly said, "I say, son," because he was deaf and didn't think anyone could hear him.

Foster was crazy about the idea. He and Bob merged the two personalities of the old sheriff and Senator Claghorn and ended up with the Foghorn Leghorn character. At first, Bob didn't think Mel Blanc could do the loudmouthed Southern voice of Foghorn, so he auditioned another voice actor. But the actor couldn't provide the voice Bob wanted, so he decided to give Blanc a try. After he described the character to him, Blanc nailed it and was the voice of Foghorn from that point on.

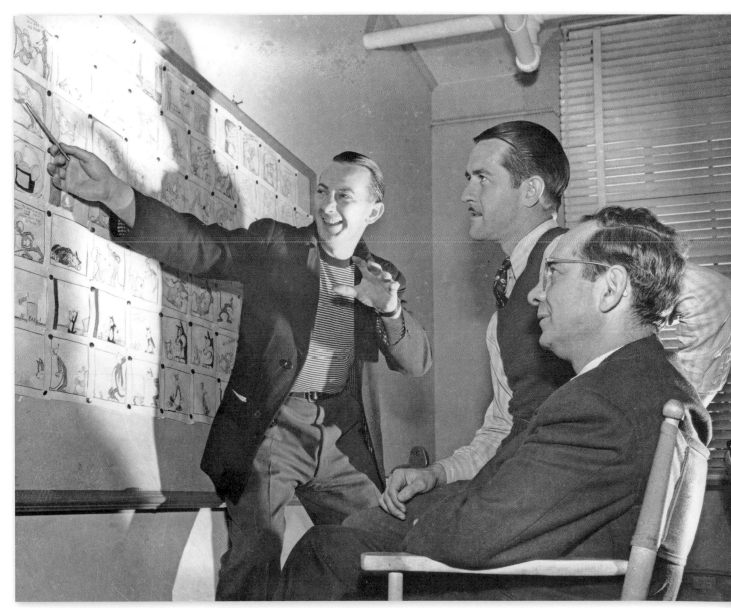

Warren Foster (standing) takes Bob McKimson and Eddie Selzer through the storyboard for "The Mouse-merized Cat," 1946.

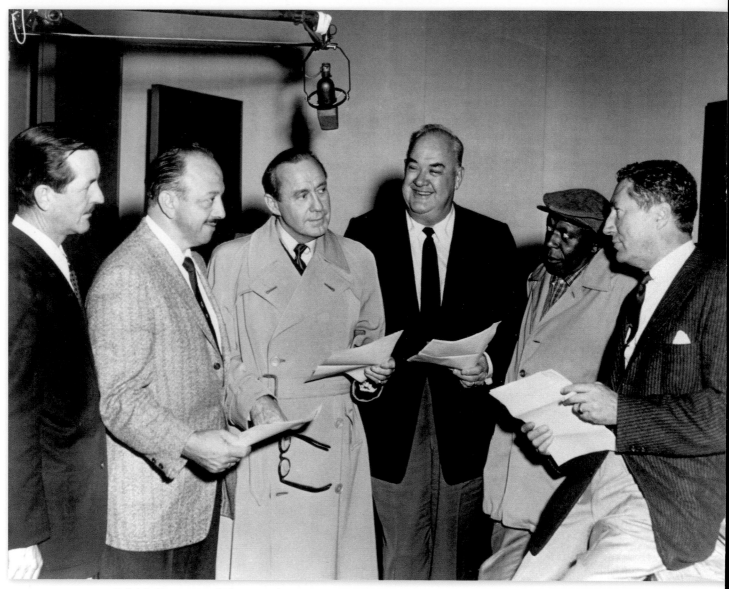

Bob McKimson, Mel Blanc, Jack Benny, Don Wilson, Eddie "Rochester" Anderson, and Tedd Pierce at a recording session for "The Mouse That Jack Built," 1958.

Bob believed Foghorn had the makings of a good character, but he knew he had to wait for the public's reaction. Needless to say, the animated rooster's first cartoon proved to be very popular and soon he became a lead character, with Henery as the secondary. Chuck, who had returned from the army that year and now worked under Bob at Warner, animated on most of the Foghorn cartoons and served as a writer on one of them.

In 1945, while stationed in New York, Chuck met and married Ruth Mandel, a native New Yorker. Once Chuck was released from the army, the couple moved to Los Angeles and settled in the San Fernando Valley area. Chuck's first screen credit at Warner Bros. was the 1947 release "Hobo Bobo." Chuck became an instrumental player in the formulation of characters and story ideas for Bob's unit. Until his departure in 1953, he animated on a total of 73 cartoons for Warner and co-wrote the 1955 Foghorn Leghorn release "All Fowled Up."

The process of story development, at least in Bob's case, varied considerably. When asked

Model sheet for "Easter Yeggs" (1947), by Bob McKimson.

how much he relied on his story men, Bob replied that it was "very hard to say." Once in a while his story man would be working on anywhere from 8 to 10 concepts at a time, and Bob might

find something in one of them that sparked an idea, so they would both go to work on that idea and end up with a completed story. Other times, Bob would come up with an idea and relate it to the story man, and they would then work on it together to get it into shape. The director and the story man had to develop the cartoon storyline together because, while the story man was responsible for writing the story, the director had the entire cartoon to think about.

After Bob worked with his story man, he would make the character layout drawings for every scene in the picture, a task that might result in 200 to 300 drawings for the entire film. A typical cartoon consisted of about 50 scenes, and each animator was given specific

Lobby card for "Easter Yeggs" (1947), directed by Bob McKimson with animation by Chuck McKimson.

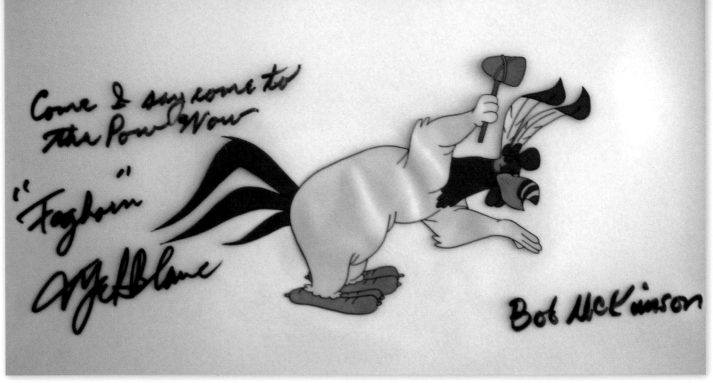

Come & say come to the Pow Wow

"Foghorn"

Mel Blanc

Bob McKimson

Original cel from "Feather Dusted" (1955), signed by Bob McKimson and Mel Blanc.

scenes to do; however, all of the animators would work off the character layout drawings so their work would appear almost identical, even though it had been drawn by different artists. In order to help capture each character's various facial expressions and match their lip movements to the soundtrack, the animators would sometimes keep mirrors at their desks, repeating the prerecorded dialogue aloud and using their own reflections as models.

Bob had a unique approach when it came to his role as a director. The other directors did character layouts and instructed their animation teams on the characters' acting and action, but they usually did not have time to do any of the actual animation themselves. Because of his strong animation background, however, Bob worked closely with his animation team and actually animated on some of the cartoons he directed.

Throughout Bob's career at Warner Bros., the studio held what they called "jam sessions" on a regular basis. During a jam session, the directors, story men, and others in the studio would put a layout of a potential cartoon up on a board and then rip the story apart, throwing and twisting new gags around until they felt they had a good story. Every cartoon was done in this way. It was only after a jam session that the director took

Lobby card for "Feather Dusted" (1955), directed by Bob McKimson with animation by Chuck McKimson.

Foghorn Leghorn
in
"FEATHER DUSTED"
A *Merrie Melodie* Cartoon
color by—
TECHNICOLOR

© WARNER BROS. CARTOONS INC.

A WARNER BROS. CARTOON

"I Say, I Say . . . Son!"

the cartoon and molded it to his own particular style. Bob felt that this was a very good way of working because it meant the same old gags wouldn't be used over and over, and new story twists could be incorporated. This made things a lot more interesting and kept the cartoons modern.

In 1946, the Hollywood Cartoonists Union had demanded and received a 25 percent pay raise for all its artists, which had helped increase some very low wage scales. However, as a result, all of the cartoon studios ended up with less money for the very labor-intensive process of animation. These changes can be seen in the films released after 1947; fewer characters appeared onscreen, and their movements became more restricted.

That year, Bob Clampett left the studio in order to pursue his own projects. He was replaced by Arthur "Art" Davis, who was to be the last director appointed of any consequence.

Lobby card for "All Fowled Up" (1955), directed by Bob McKimson.

Left to right: Bob McKimson, Chuck Jones, David DePatie, Friz Freleng, and production manager Bill Orcutt.

What's Cookin', Doc?

By JEAN BLANCHARD

Jean Blanchard

It seems to have been a well kept secret but your favorite record shop is featuring an album of records of all your favorite little folks. The three records feature BUGS BUNNY, PORKY PIG, ELMER FUDD and DAFF DUCK. The stories are by TEDD PIERCE and WARREN FOSTER. Of course, MEL BLANC does the voice characterizations. It's a must for the kid's Christmas stockings.

This Month's Thumbnail Sketch

It's unusual to have one talented member in a family of five children, but the McKimson family can boast three artists. Tom McKimson, former layout man for Warner's now does the Merrie Melodies and Looney Tunes Cartoon book. Chuck is an animator in the McKimson unit and middle brother, Bob, is a Director.

Bob was born thirty-six years ago in Denver, Colorado. On visit to California in 1921 sold the family on California. Five years later Bob moved to California to stay. Bob's father, who has been in the printing trade for fifty years, insisted that all three of the boys learn the trade from the bottom up. Strangely enough, it was their artist mother's influence that determined the boy's eventual chore. They all showed an aptitude for drawing from the time they started decorating their school books in the first grade. Bob studied art with the Lukits School of Art. Recently the three boys collaborated on a book of their mother's charming children's stories.

Fourteen years ago Bob married Viola Feley. They have the ideal family in their Hollywood home. Bobby Junior boasts nine years and his sister, Marlyn is two years younger.

He started in the cartoon business at Disney's and then worked for a while in an ill-fated cartoon deal with Romer Gray, son of the late Zane Gray. Bob started making cartoons for Warner Bros. in 1931, which makes him the oldest employee in length of service.

Bob is a fine athlete dividing his time between golf and bowling. Te

Bob McKimson

carries an average in bowling of 176 and shoots golf in the 90's. For several years Bob played polo but, "I was never able to make more than a two goal rating," he laments. Bob and

E.T.

It Couldn't Happen Here But Did Department

Over a year ago FRED HELLMICH came to Warner's under the G. I. Training bill. Never in all that time has Fred's name appeared in print and he has often dropped a hint. My reply to his lament was always, "do something, Freddie, do something.

Freddie did! He got his nose caught in a folding wall bed. Honest. His nose, never of a size to be overlooked, now resembles an illustration for the story, "How the Elephant Got His Trunk." He should have stood in bed.

polo mallet attempted to occupy the same fraction of space at the same time, resulting in a smashed jaw. That wasn't enough for Bob, he had to go back for more and suffered several nasty spills in that dangerous game. If the polo club hadn't disbanded, Bob would probably still be playing and trying to smash records and his jaw.

Bob was particularly thrilled by having his fourth directed picture, "WALKY TALKY HAWKY" nominated for the Academy Award. He's doing a splendid job as a director and turning out surelaugh cartoons with his story mon, Warren Foster, with surprising regularity.

The Guys and Gags Department

DON WILLIAMS dropped twenty pounds and looks ten years younger. . . . HERMAN COHEN and his lovely wife are parenticipating. . . . BOB McKIMSON started off his vacation with a smash. Five minutes after leaving the studio, he was in an accident, smashing up his car and breaking his wife's foot. Mrs. McKimson will be on the inactive list for several weeks yet. . . . RAY EMLER enjoyed all of his trip home to Kansas City except driving through New Mexico. Everything that could happen to his car happened in that state—both coming and going. . . . ANNE HERSHENBURGH looks like a blue-eyed Indian after her vacation AND that new hair-do she's sporting. You ain't seen nothin' unless you've seen IT. . . . PEGGI MORGAN spent her vacation on the desert and she's even darker than Anne, if that's possible. . . . CHUCK McKIMSON lost thirteen pounds digging post-holes on his Tarzana Ranch. . . . This summer's exces-

sive heat brought out a flock of guys in shorts. Among those treating the gentle sex to a peek at their furry gams were EMERY HAWKINS, DICK THOMPSON, ACK MILLER, BOB GRIBBROEK, BILL MELENDEZ and GEORGE GRANDPRE' . . . AND . . . even if she is wearing shorts, it still looks funny seeing MILLIE BERGER putting on her dress in public after her sun bath. . . . IVY CAROLL CHRISTENSEN modeled all the authentic polkas for GERRY CHINIQUY's animation in the forthcoming "Mouse Mazurka." . . . LOIS WAGGONER and TONI DENNY have left the studio. Toni was recently named "Shutter Girl" at the San Fernando

(Continued on Page 16)

Marvin the Martian

An alien whose appearance is based on the Roman god Mars, Marvin the Martian was created by Chuck Jones and writer Mike Maltese. Donning a Roman-style helmet, a war skirt, and a pair of sneakers, Marvin and his dog, K-9, try to destroy Earth but are repeatedly thwarted by Bugs Bunny. Even though Marvin has no mouth, he speaks in a high, nasal voice courtesy of Mel Blanc.

Marvin first appeared in the Jones cartoon "Hare-devil Hare" in 1948. Only four classic Marvin cartoons were made after that.

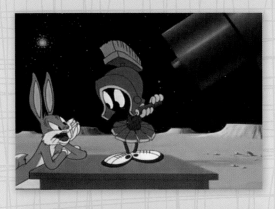

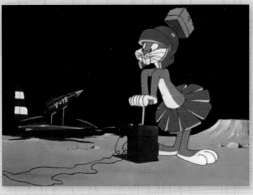

Above and right: **Animation stills from "Haredevil Hare" (1948).**
Below: **Pen-and-ink drawing by Tom McKimson, early 1990s.**
Opposite: **A page from the Warner Bros. Cartoons in-house newspaper, September 1947.**

Davis's unit was discontinued in 1949, however, and he became an animator for Freleng's unit. This left Bob, Freleng, and Jones as the primary directors, each producing one-third of the total yearly cartoons.

In 1948, the animated character Marvin the Martian first appeared in a Chuck Jones cartoon called "Haredevil Hare." Teamed with Bugs Bunny, this little helmeted Martian was originally unnamed; later, he was christened "Marvin" by Jones.

The final major *Looney Tunes* characters created in the 1940s were Road Runner and Wile E. Coyote, first paired up in the 1949 Chuck Jones cartoon "Fast and Furry-ous." The story goes that Jones and writer Mike Maltese thought if would be funny to do a parody of cartoon chase scenes. The cartoons are mostly set in the Southwestern desert and feature Wile E. constantly chasing Road Runner, but never catching him. The only dialogue ever uttered by Road Runner is "beep, beep."

Lobby card drawing for "Hurdy-Gurdy Hare" (1950) by Bob McKimson.

Road Runner and Wile E. Coyote

Road Runner and Wile E. Coyote, both created by Chuck Jones and writer Mike Maltese, first appeared in "Fast and Furry-ous" (1949), directed by Jones. Wile E. Coyote (once known simply as "Coyote") is on a never-ending hunt for Road Runner, chasing him continuously through the Southwestern desert. The coyote is always utilizing various devices made by the Acme Corporation in hopes that they will help him catch Road Runner. Like many cartoon characters, Road Runner has the ability to alter reality, often entering a painted image on a rock as if it were a continuation of the scenery. Wile E. Coyote, on

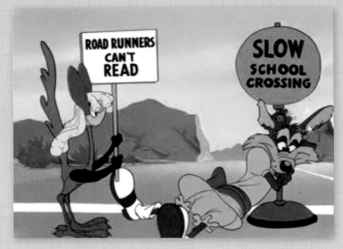

Animation still from "Fast and Furry-ous" (1949).

the other hand, does not have this ability, and slams into the rocks while in hot pursuit. The coyote speaks occasionally but is generally silent, while Road Runner's vocabulary is limited to a succinct "beep, beep."

A total of 30 classic *Looney Tunes* cartoons were made featuring Road Runner and Wile E. Coyote. Bob McKimson directed the last classic cartoon for the dynamic duo, "Sugar and Spies" (1966).

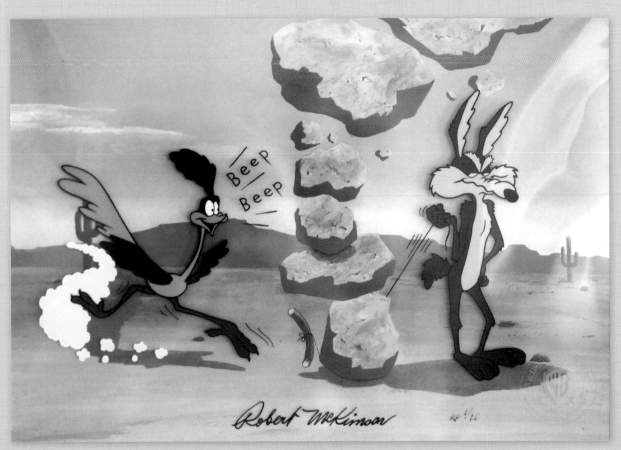

Limited edition cel from original drawing by Bob McKimson.

Hippety Hopper

A baby kangaroo that has escaped from the zoo, Hippety Hopper was created by Bob McKimson and first introduced in the 1948 cartoon "Hop, Look and Listen." The character is teamed with Sylvester, who thinks Hippety is a giant mouse. Needless to say, the kangaroo continually gets the better of Sylvester, who fancies himself a master mouse-catcher but always ends up getting beaten by Hippety.

The kangaroo was first paired with both Sylvester Jr. and Sylvester in the 1950 release "Pop 'im Pop!" Hippety Hopper appeared in 13 classic *Looney Tunes* cartoons.

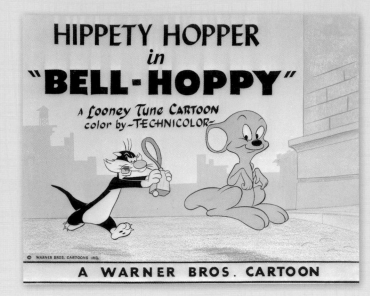

Above: **Lobby card for "Bell-Hoppy" (1954), directed by Bob McKimson with animation by Chuck McKimson.**
Right: **Layout drawing for "Hippety Hopper" (1949) by Bob McKimson.**
Below: **Model sheet by Bob McKimson.**

"I Say, I Say . . . Son!"

Above: Layout drawing for "Hippety Hopper" (1949), directed by Bob McKimson
with animation by Chuck McKimson.
Below: Layout drawing for "Lighthouse Mouse" (1955), directed by Bob McKimson
with animation by Chuck McKimson.

Overleaf: Limited edition cel from "Rabbit's Kin" (1952),
directed by Bob McKimson with animation by Chuck McKimson.

IN

ROLIE "99

WARNER BROS. CARTOONS

1106

Lobby card pencil drawing for
"A Ham in a Role" (1949), directed
by Bob McKimson with animation by
Chuck McKimson.

Layout drawing (above) and animation still (below) from "French Rarebit" (1951), directed by Bob McKimson with animation by Chuck McKimson.

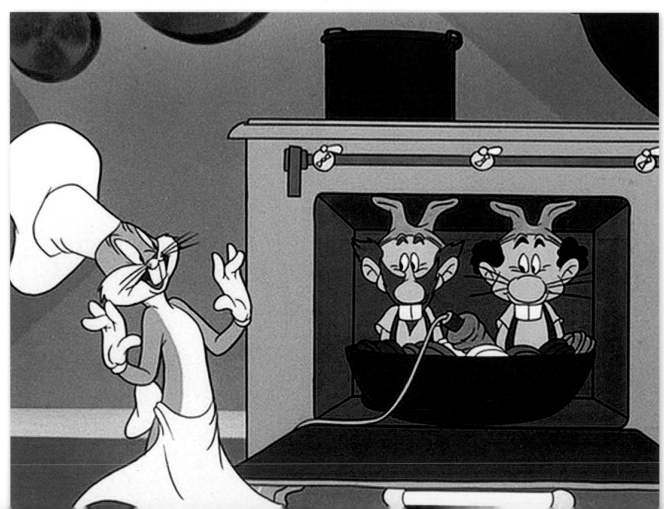

In 1950, fan favorite "Hillbilly Hare," directed by Bob, was released. Later censored for its violent content, the cartoon features Bugs Bunny, who is vacationing in the Ozarks and encounters two feuding hillbillies. The hillbillies chase Bugs around the wilderness until he begins to impersonate a country fiddler, fooling the hillbillies into starting a square dance. The yokels follow every command Bugs gives during the song and end up abusing each other. This cartoon was written by Tedd Pierce and features backgrounds by the talented Richard Thomas.

Bob and all the Warner Bros. directors used plays on words in many of their cartoon titles. Some of these titles included "Hollywood Canine," "One Meat Brawl," "Birth of a Notion," "Easter Yeggs," "Swallow the Leader," and "What's My Lion?" Because Warner Bros. cartoons were made for adults, not children, their intended audience is able to appreciate additional gags, hidden innuendos, and plays on words. During the 1950s, *Looney Tunes* audiences were transitioning from unruly kids to responsible adults. By that time, the Warner Bros. artists and directors had also aged, leading to characters who were more calm and less scatterbrained.

By 1950, Bob had created another new character, Sylvester Jr., who is a scaled-down version

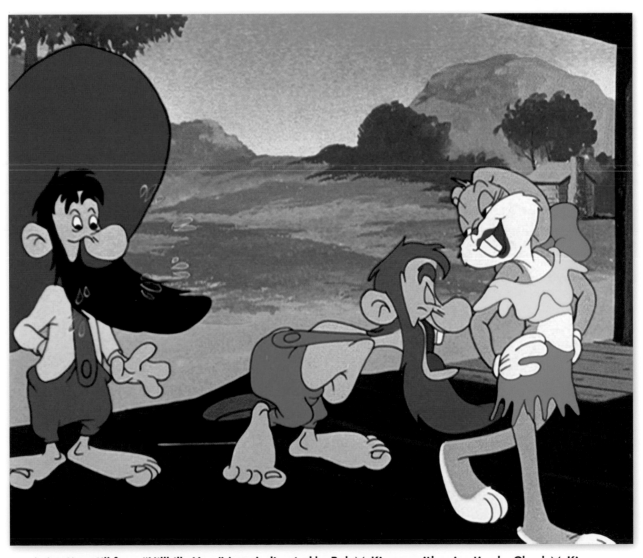

Animation still from "Hillbilly Hare" (1950), directed by Bob McKimson with animation by Chuck McKimson.

Layout drawing for
"Hillbilly Hare" (1950),
directed by Bob McKimson with
animation by Chuck McKimson.

Overleaf: Limited edition cel
from "Hillbilly Hare."

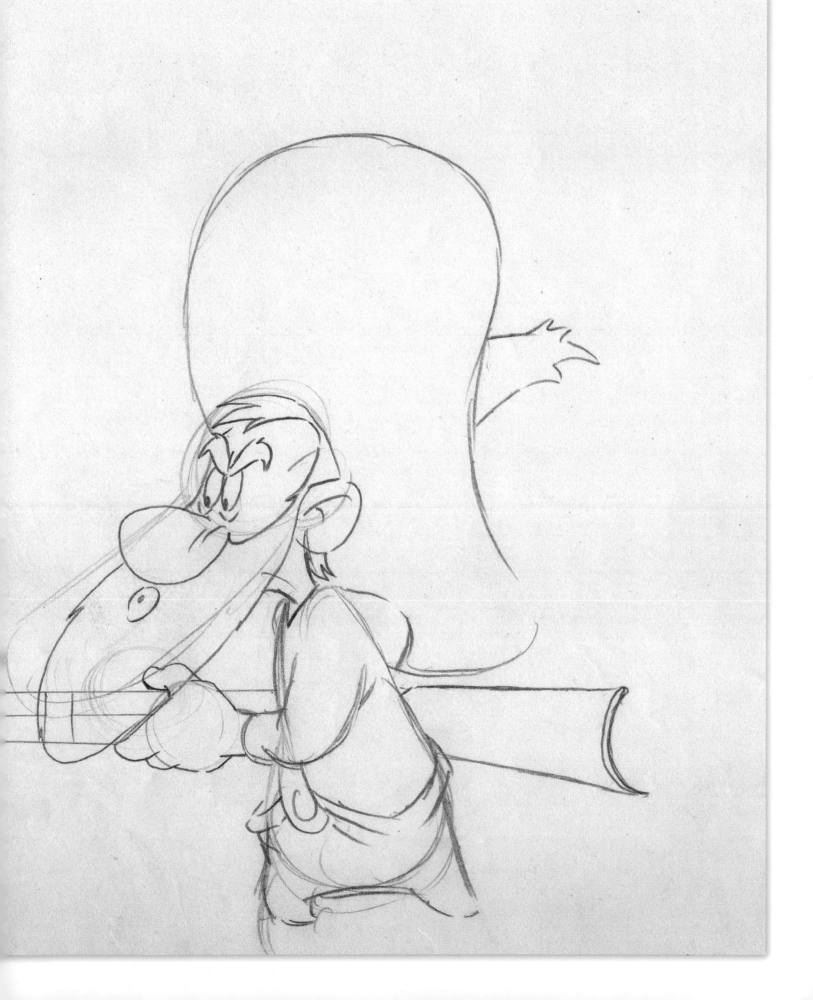

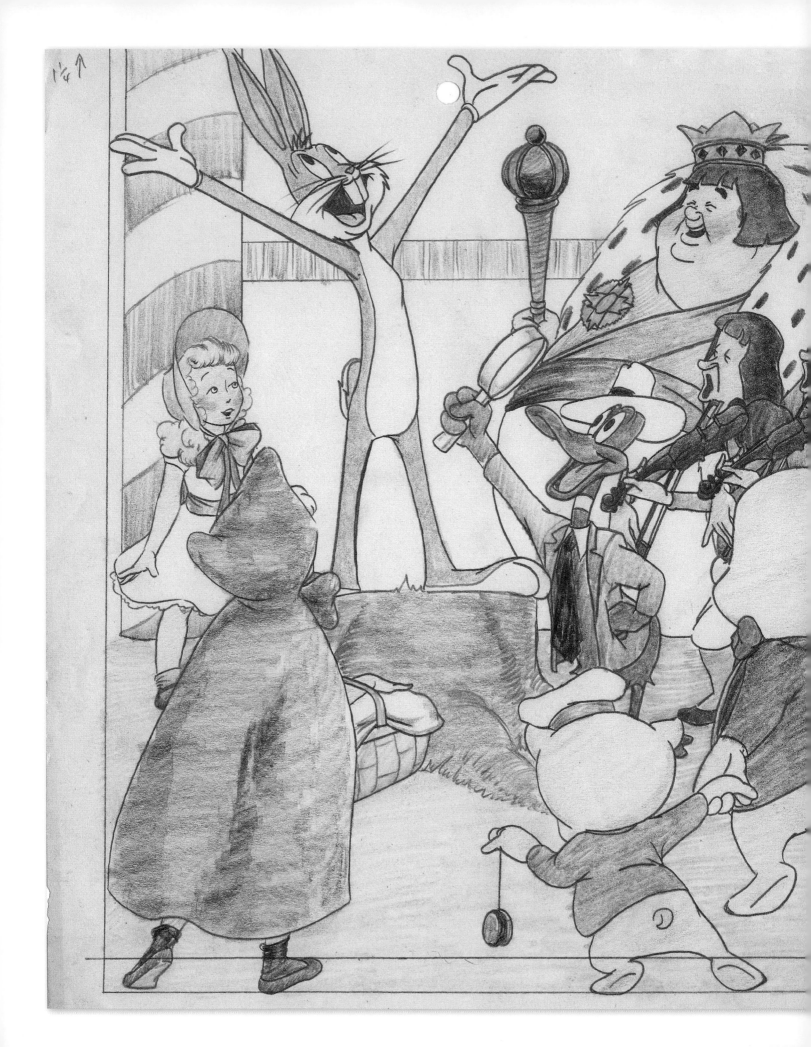

Pencil drawing for the cover of the
Capitol Record Reader *Bugs Bunny in
Storyland*, by Bob McKimson, 1949.

Pencil drawing for interior cover of the Capitol Record Reader *Bugs Bunny in Storyland*, by Bob McKimson, 1949.

Above: **Pencil drawing for the Capitol Record Reader** *Bugs Bunny and the Tortoise,* **by Bob McKimson, 1948.**
Below: **Pencil drawing for the Capitol Record Reader** *Bugs Bunny in Storyland,* **by Bob McKimson, 1949.**

of his father. Junior was a very successful character and was initially featured, along with Sylvester and Hippety Hopper, in the cartoon "Pop 'im Pop!," released in 1950. In the cartoon, Sylvester brags to Junior that he can catch a giant mouse, who is, in fact, Hippety Hopper. Needless to say, Sylvester is unable to catch the "mouse" and Junior is continuously ashamed by his father's ridiculous attempts. These three characters worked so well together that Bob paired them up in several more cartoons.

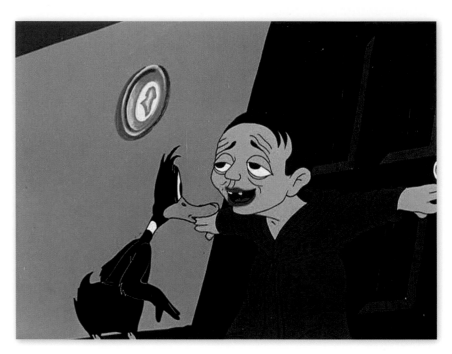

Right: Animation still from "Birth of a Notion" (1947), directed by Bob McKimson.
Below: Pencil drawing by Bob McKimson.

"I Say, I Say . . . Son!"

Sylvester Jr.

Sylvester Jr., the son of Sylvester, was created by Bob McKimson and first appeared in the 1950 cartoon "Pop 'im Pop!" His body is a miniature version of Sylvester's, but his disproportionately large head is the same size as his father's. Sylvester Jr. is a stereotypical child, embarrassed by his parent; his father's continuous failed attempts to capture Hippety Hopper leave Junior muttering, "Oh, father." Sometimes he even goes so far as to wear a paper bag over his head. Like his dad, Sylvester Jr. has a lisp voiced by Mel Blanc, but it isn't as juicy as Sylvester's and has more of a "th" sound than a "sth." Sylvester Jr. appeared in 12 classic *Looney Tunes* cartoons.

Watercolor drawing by Bob McKimson, 1970s.

POP 11M
POP

Above: Model sheet for
Sylvester Jr., circa 1950s.
Right: Limited edition sericel from
original drawing by Bob McKimson.

Above: Lobby card for "Freudy Cat" (1964), directed by Bob McKimson.
Below: Limited edition cel from original drawing by Bob McKimson.

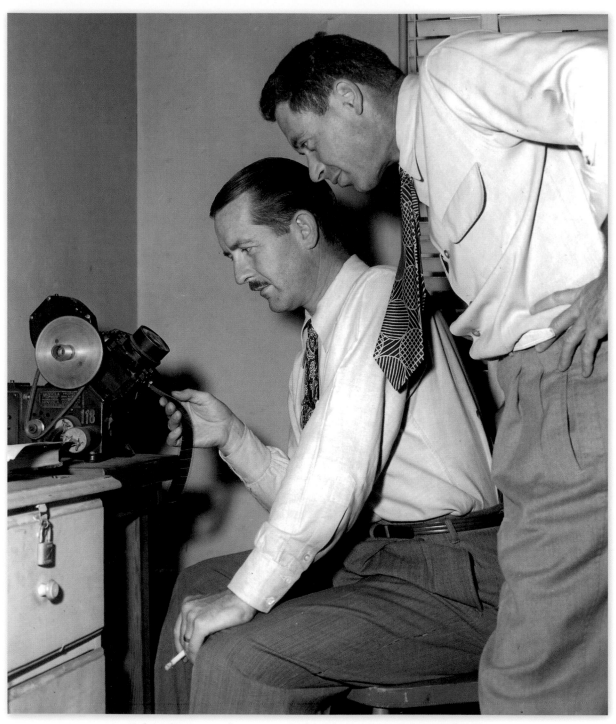

Bob McKimson and animator Rod Scribner reviewing a pencil test.

In 1951, Bob directed "Early to Bet," the only cartoon to feature a character called the Gambling Bug. The dapper little bug, who wears a jacket and bow tie, infects others with a desire to gamble. In "Early to Bet," his victim is a nameless cat who continues to gamble his money away after being bitten by the bug. The cartoon teaches a lesson about gambling, warning audiences to avoid being bitten by the "Gambling Bug" in real life.

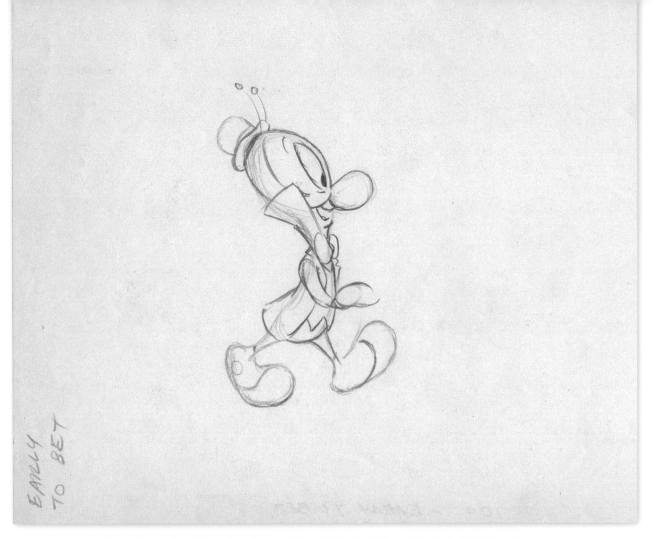

EARLY
TO BET

Layout drawing (above) and animation still (below) from "Early to Bet" (1951),
directed by Bob McKimson with animation by Chuck McKimson.

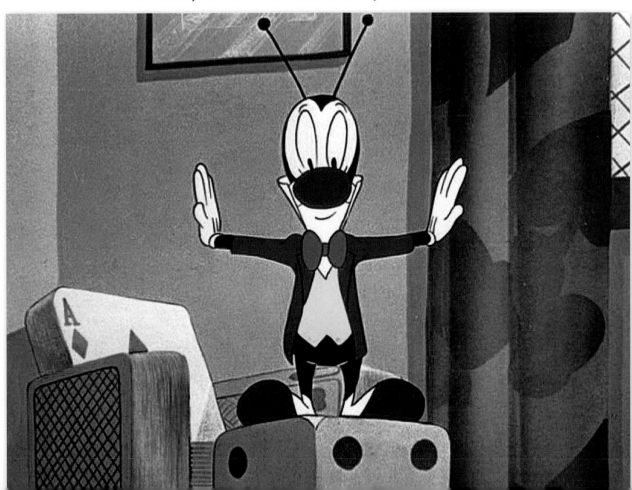

Bob McKimson at his animation desk, early 1960s.

Debuting in 1953 was another new character of Bob's named Speedy Gonzales. Unlike the Speedy we know today, the original character wore no hat and had a gold front tooth. Speedy originated from an off-color story told to my father about a personality called Speedy Gonzales. At the time, Bob's story man was working on a cartoon featuring an unnamed mouse. Bob related the off-color story to his writer, Tedd Pierce, and the mouse character became Speedy Gonzales, "the fastest mouse in all Mexico." Speedy's *"arriba, arriba"* line came from two Mexican brothers who played polo with Bob and used to yell the phrase when charging down the polo field.

Speedy Gonzales was first used in the 1953 cartoon "Cat-Tails for Two," a story written by Pierce that is loosely based on John Steinbeck's *Of Mice and Men*. In the cartoon, two brain-dead cats are out looking for something to eat when they discover a mouse (Speedy) aboard a Mexican ship who repeatedly outsmarts them. After the cartoon's release, Speedy remained unused for two years until Friz Freleng and his layout man, Hawley Pratt, redesigned the character, adding a sombrero and subtracting the gold tooth for the 1955 release "Speedy Gonzales," which paired Speedy with Sylvester. The cartoon won an Academy Award, and the character was used in many shorts after that, including the Oscar-nominated 1957 release "Tabasco Road," directed by Bob.

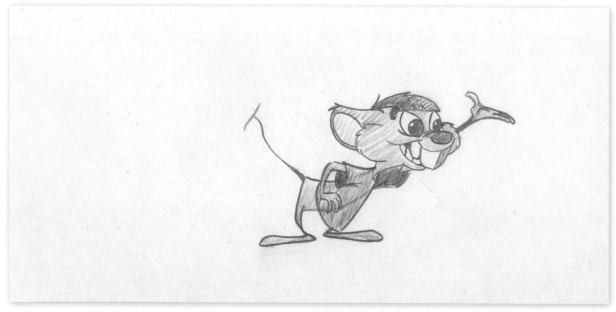

Above: Layout drawing of the original Speedy Gonzales for "Cat-Tails for Two" (1953).
Opposite: Original watercolor drawing by Bob McKimson, early 1970s.

Overleaf: Limited edition cel of Speedy Gonzales.

1951

© WARNER BROS. PICTURES INC.

BB-1448

Publicity art featuring the original Speedy Gonzales, 1951.

"I Say, I Say . . . Son!"

Speedy Gonzales

Speedy Gonzales, "the fastest mouse in all Mexico," was created by Bob McKimson and first introduced in the 1953 cartoon "Cat-Tails for Two." The original Speedy wore no hat and had a gold tooth. Later, director Friz Freleng and his layout man, Hawley Pratt, re-designed the character, taking out the gold tooth and adding a sombrero.

In the Speedy Gonzales cartoons, Sylvester was soon set up as Speedy's regular nemesis in a series of ongoing shorts directed by Freleng and Bob. The character appeared in a total of 45 classic *Looney Tunes* cartoons.

Right: **Drawing by Bob McKimson.**
Below: **Animation still from "A Message to Gracias" (1964), directed by Bob McKimson.**

SPEEDY GONZALES

Above: The original Speedy Gonzales in an animation still from "Cat-Tails for Two" (1953),
directed by Bob McKimson with animation by Chuck McKimson.
Below: Layout drawing of the original Speedy Gonzales, by Bob McKimson.

"I Say, I Say . . . Son!"

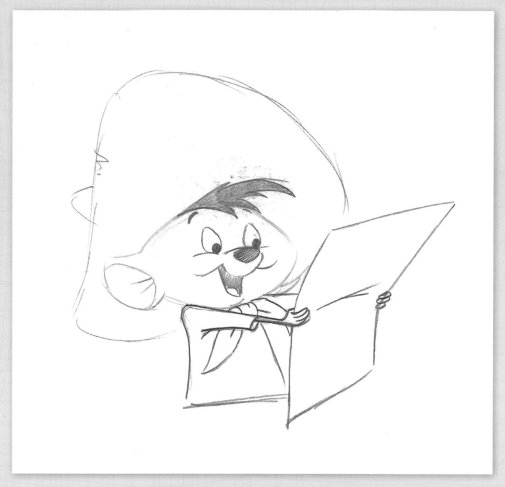

Above: Layout drawing by Bob McKimson.
Below: Lobby card for "Cannery Woe" (1961), directed by Bob McKimson.

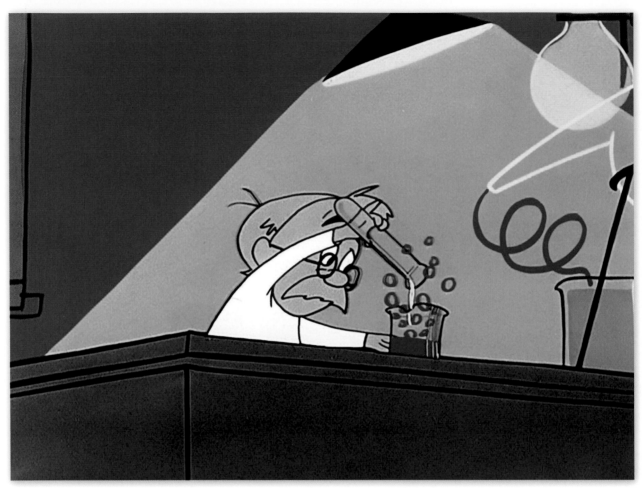

Animation still from "The Hole Idea" (1955), directed and animated by Bob McKimson.

In 1953, Jack Warner had the cartoon studio closed down due to the new 3-D phenomenon that was sweeping the nation. Warner believed 3-D would become the norm in all the movies and that animated shorts would be too costly to produce using this process. After about six months, Warner realized he had misjudged the durability of 3-D and reopened the studio. During its closure, however, many of the studio's talents had relocated to other production companies.

It was at this time that Chuck moved to Western Publishing to work with Tom. Unfortunately, when Warner closed, Bob had just developed a cartoon called "The Hole Idea" that was ready to be animated, but he didn't know if the Warner studio would ever reopen. Since he no longer had Warner Bros. animators on hand, he decided to animate the cartoon himself. After the Warner studio reopened, Bob's cartoon was released in 1955 and received more attention than almost any other cartoon he had ever made. The short reportedly confused some viewers because it didn't include the usual gags and also featured humans instead of the regular cast of animal characters. Written by story man Sid Marcus, the cartoon is about a "portable hole" invented by a scientist named Calvin Q. Calculus. The hole, however, is stolen and ends up being used for evil purposes. This was one of my father's favorite cartoons, one that he considered to be clever and different.

Before the studio closed in 1953, Bob, Chuck, and some of the other animators had begun designing a new character that was very different from the others—the Tasmanian Devil, the last

Above and below: Model sheets for "The Hole Idea" (1955) by Bob McKimson.

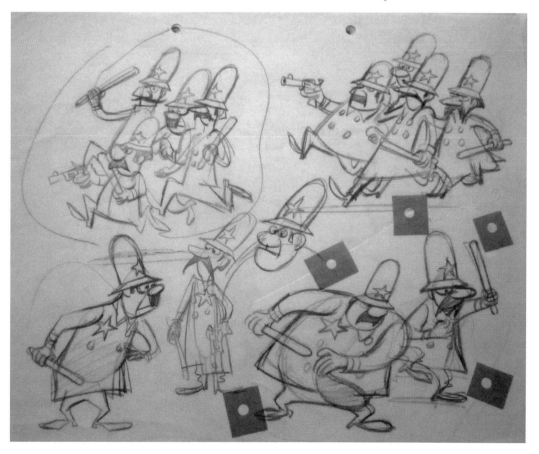

of the major *Looney Tunes* characters to be developed. The Tasmanian Devil eventually became one of the most popular characters in the *Looney Tunes* lineup.

At the time, my father had wanted to create a new character that would be a refreshing change from the other *Looney Tunes* characters. The studio had already used rabbits, mice, ducks, birds, and all sorts of other more commonplace animals, and Bob wanted something that would stand apart from the others. One day, Bob, a crossword puzzle fanatic, came across "Tasmanian devil" in one of his puzzles. In 1954, Bob, Chuck, and some of the other animators began designing a character based on this uncommon animal. No one in the studio had ever heard of a Tasmanian devil before,

Right: Bob McKimson pictured in front of a storyboard for "Bill of Hare," 1961.
Below: Lobby card for "Devil May Hare" (1954), directed by Bob McKimson with animation by Chuck McKimson.

so Bob asked all of them to research the marsupial and come up with their own cartoon interpretations of it. Apparently, all of the animators came up with similar stylized drawings of the animal. My father used these and his own characterization to create the final drawing of the Tasmanian Devil as we know him today.

Taz was first introduced in the 1954 release "Devil May Hare," in which he devours everything in sight while moving through the landscape in the form of a whirling, gyrating tornado. At the end of the cartoon, Bugs Bunny places a want ad for a "Lonely Lady Devil." When the female arrives by plane, Bugs, dressed as a minister, marries off the two Tasmanian devils.

After the cartoon's debut, Eddie Selzer said he didn't like the Tasmanian Devil and didn't want my father to make any other cartoons featuring the character. That would have been the end of the Tasmanian Devil, had it not been for the numerous letters flooding into the studio, asking for more Taz cartoons. Jack Warner became aware of the letters and asked Selzer why they weren't making more Tasmanian Devil cartoons. Selzer replied that he thought Taz was an obnoxious character and had told Bob not to make any more cartoons featuring him. Warner said, "To hell with that, let's get going and make some more." Four more Tasmanian Devil cartoons were produced, beginning with the 1957 releases "Bedevilled Rabbit" and "Ducking the Devil." The last two Tasmanian Devil cartoons were "Bill of Hare," released in 1962, and "Dr. Devil and Mr. Hare" in 1964.

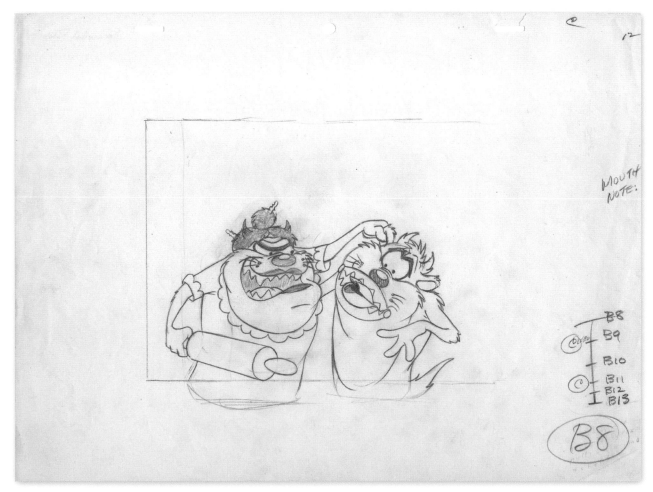

Animation drawing for "Bedevilled Rabbit" (1957), directed by Bob McKimson.

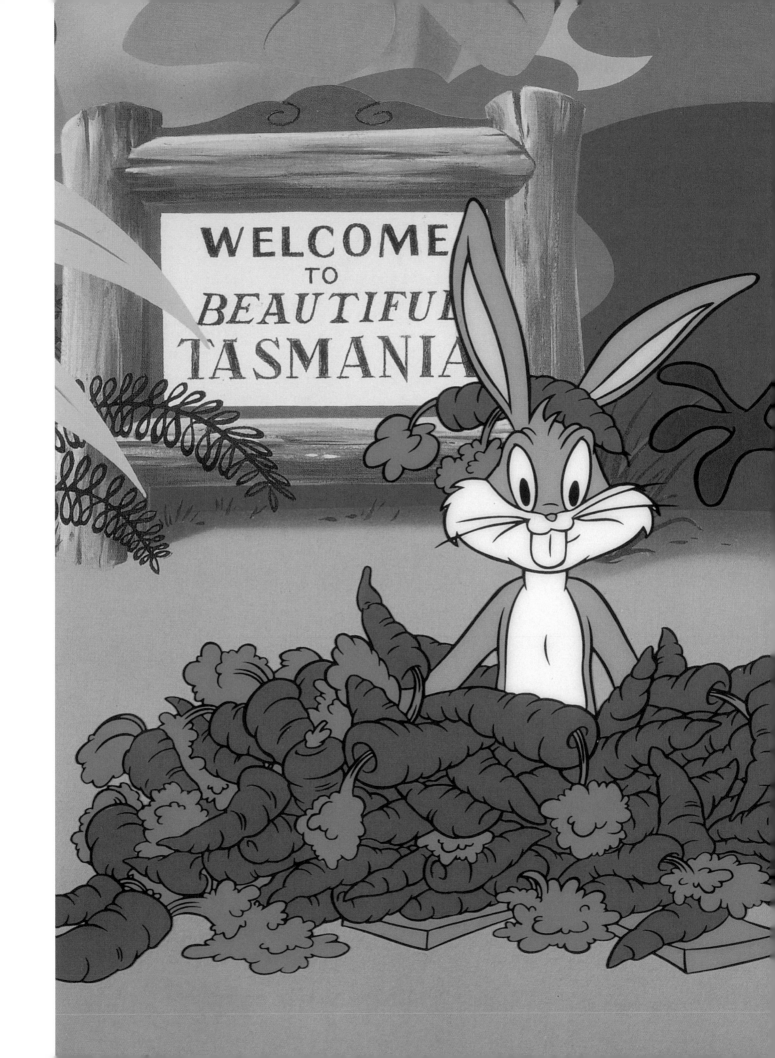

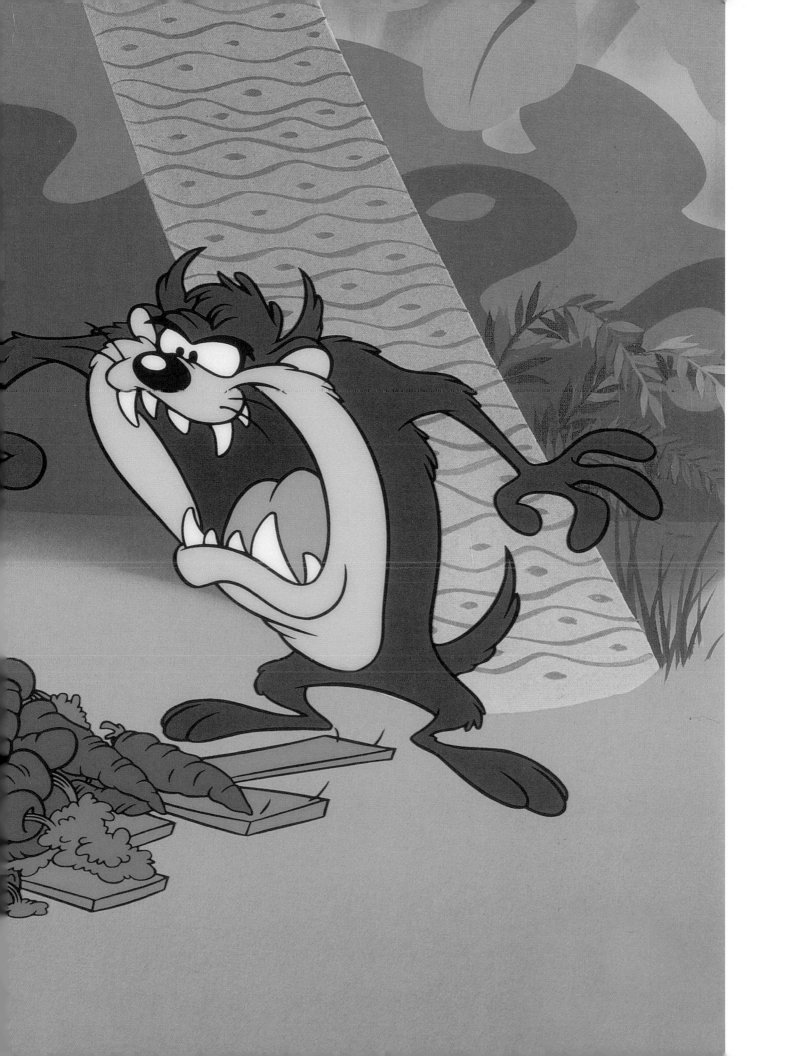

Tasmanian Devil

Created by Bob McKimson and his unit, the Tasmanian Devil was the last major *Looney Tunes* character. Taz first appeared in the 1954 cartoon "Devil May Hare," which also featured Bugs Bunny. The character is based on the Australian marsupial of the same name, but in reality bears little to no resemblance to the actual animal. Charmed by his crazed behavior, hyperactive whirling, and insatiable hunger, audiences fell in love with Taz, propelling the character to cult status. Taz appeared in five classic *Looney Tunes* cartoons.

Limited edition cel from "Bedevilled Rabbit" (1957).

Model sheet, circa 1950s.

"I Say, I Say . . . Son!"

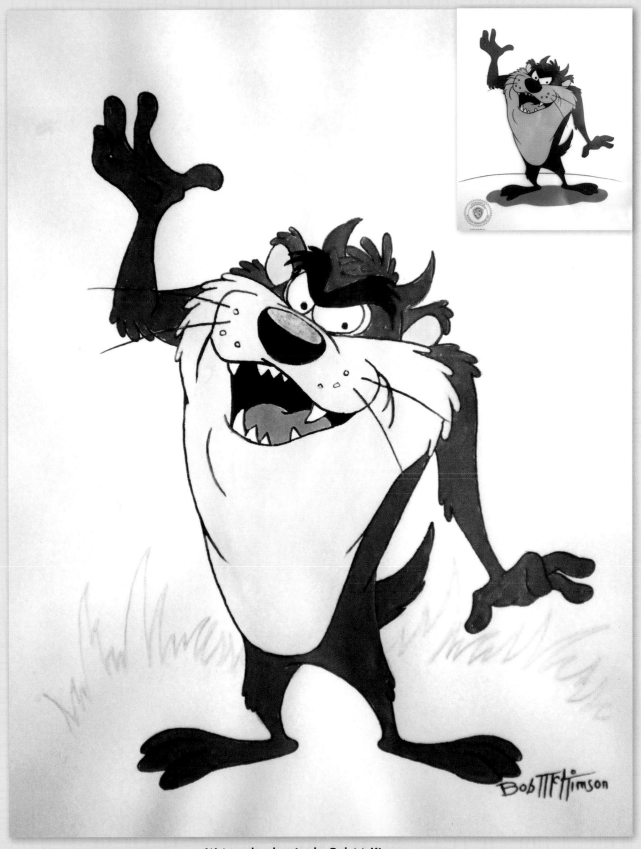

Watercolor drawing by Bob McKimson.
Inset: Limited edition sericel from original drawing by Bob McKimson.

Limited edition cel from
"Dr. Devil and Mr. Hare" (1964),
directed by Bob McKimson.

Left: Watercolor drawing by Chuck McKimson, early 1990s. *Below:* Color model drawing for "Bill of Hare" (1962), directed by Bob McKimson.

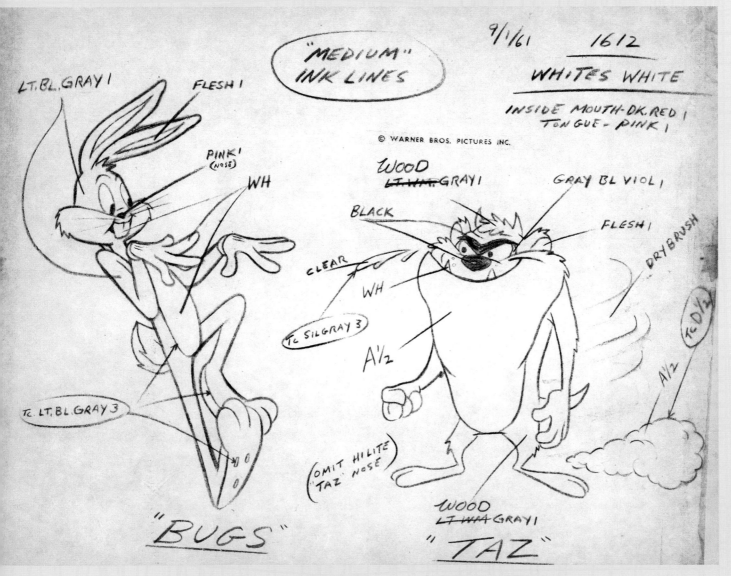

Right: Lobby card for "Dr. Devil and Mr. Hare" (1964), directed by Bob McKimson.
Below: Color model drawing for "Ducking the Devil" (1957), directed by Bob McKimson.

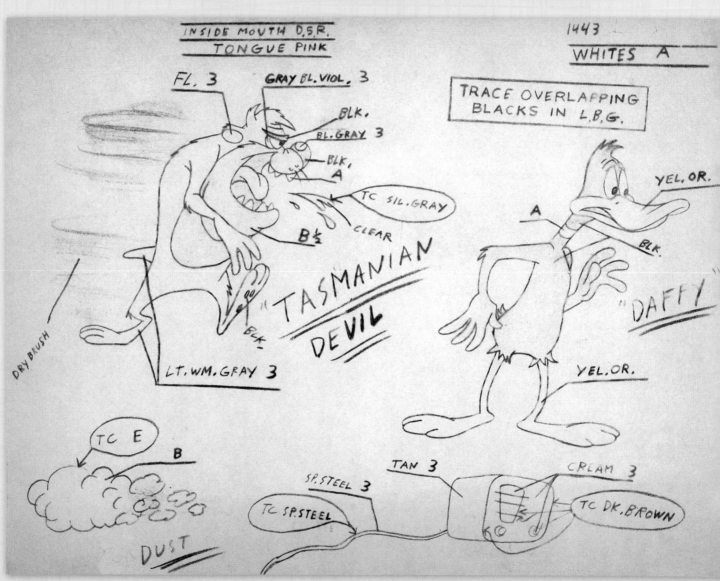

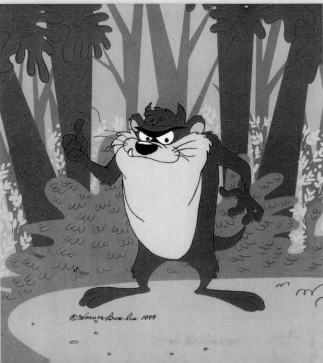

Above: Watercolor drawing by Chuck McKimson, early 1990s.
Right: Limited edition cel from original drawing by Bob McKimson.

"I Say, I Say . . . Son!"

During this period and throughout the 1950s, a director would, on many occasions, take the same basic situation in one cartoon and re-work it for another one, giving it a new twist. Warner Bros. made many "Little Red Riding Hood" spoofs, all different and all funny. There were dozens of ways to twist the same story by using different characters, different situations, etc. Usually a director would try to stick to the same sort of overall plan, trying to get the most humor out of it while still maintaining a good beginning, build-up, and ending.

From the mid- to late-'50s, my father began to use parodies in his cartoons derived from contemporary television shows. These included "The Super Snooper," "Stupor Duck," "Boston Quackie," "China Jones," and "People Are Bunny." Unfortunately, many of these did not age well, since the satirical references were lost with time. However, during that period two famous cartoon parodies were made, the first being "The Honey-Mousers," released in 1956. The cartoon was based on the television show *The Honeymooners*, starring Jackie Gleason. Bob drew up animated mice characters to portray each character in the *Honeymooners* cast, and Tedd Pierce wrote the story. The mouse version of Alice Kramden was voiced by June Foray, who had done many of the female voice-overs for Warner Bros. Cartoons, while the Ralph Kramden and Ed Norton characters were voiced by Daws Butler.

Apparently, when Jackie Gleason learned about "The Honey-Mousers," he was not happy.

Lobby card for "China Jones" (1959), directed by Bob McKimson.

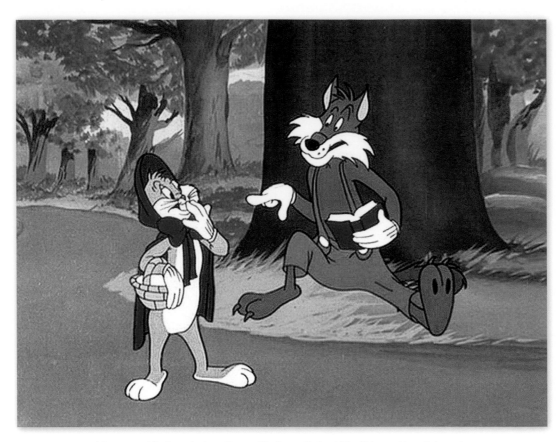

Above and below: Animation stills from "The Windblown Hare" (1949), directed by Bob McKimson with animation by Chuck McKimson.

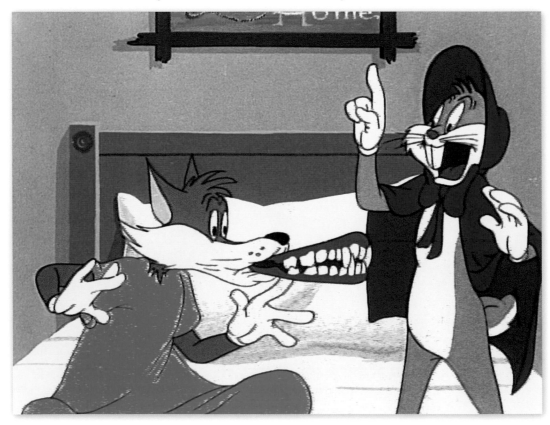

"I Say, I Say . . . Son!"

"Now wait a minute," he said, "I don't know if I want you to make these things or not. You get that picture down here and I want to see it." Gleason then got a group together to view the cartoon. Soon enough, he was laughing himself silly. "Boy," he said, "leave this alone. Make as many of them as you want." Two more "Honey-Mouser" parodies were made after that: "Cheese It, the Cat!" (1957) and "Mice Follies" (1960).

The second well-known cartoon parody came about after the famous radio and television comedian Jack Benny saw "The Honey-Mousers." Benny made it known that he also wanted a parody cartoon done, this time starring himself and his cast. They even offered to do their own voice-overs for union-scale wages. Soon, Bob and his unit were putting together "The Mouse That Jack Built," released in 1959. The cartoon features Benny and various cast members from his television program in mouse form. Bob set "The Mouse That Jack Built" apart from "The Honey-Mousers" by including a live action sequence at the end of the cartoon, featuring Benny himself waking up from his animated "dream." Bob later recalled that at one point a voice-over

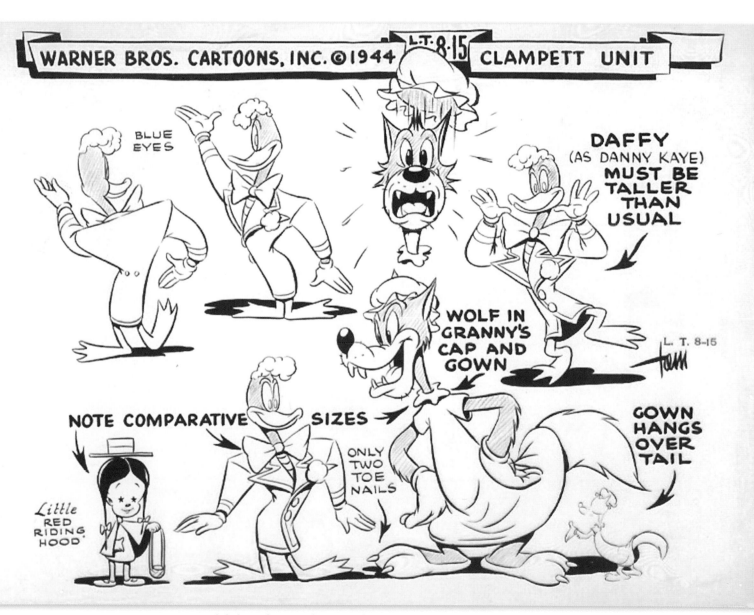

Model sheet for "Book Revue" by Tom McKimson, 1944.

Layout drawing (above) and animation still (below) from "The Super Snooper" (1952),
directed by Bob McKimson with animation by Chuck McKimson.

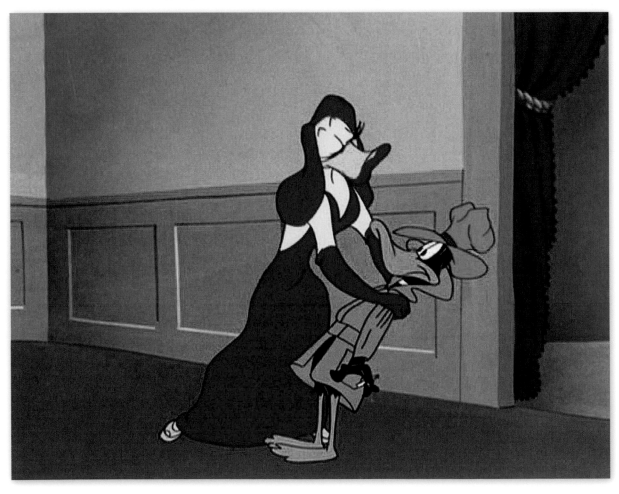

"I Say, I Say . . . Son!"

Front row: (left to right) Johnny Burton, Eddie Selzer, and Friz Freleng.
Back Row: (left to right) Treg Brown, Bob McKimson, Tedd Pierce, and Chuck Jones, early 1950s.

by Mary Livingstone, Benny's wife and costar, needed to be re-recorded, but Livingstone had refused to go back to the studio. So the Warner Bros. crew had to do the recording at the Benny residence on North Roxbury Drive in Beverly Hills, which was just a mile or so up the street from Bob's house.

In 1955, the studio moved from its previous location off Sunset Boulevard in Hollywood to a building on the backlot of the main Warner Bros. studio in Burbank. Certainly, by the beginning of the 1960s, the Golden Age of Animation had finally come to an end; after that point, the Warner

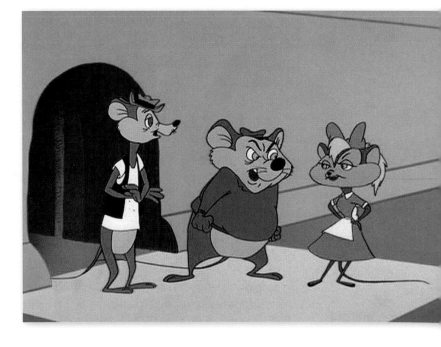

Animation still from "The Honey-Mousers" (1956), directed by Bob McKimson.

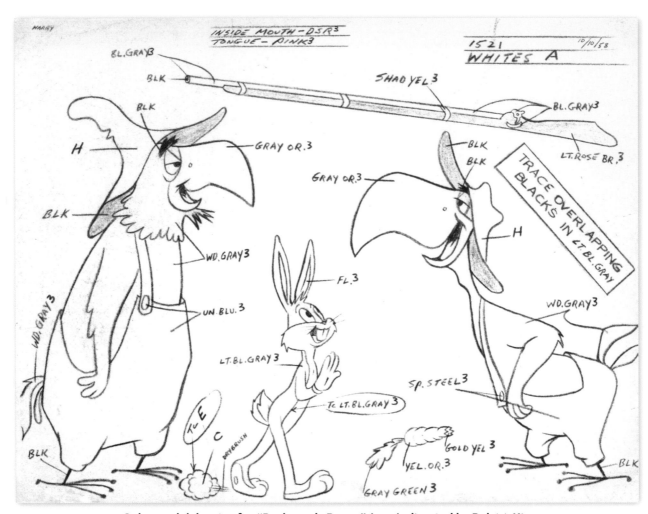

Color model drawing for "Backwoods Bunny" (1959), directed by Bob McKimson.

Limpet, who transforms into an animated talking fish and helps the U.S. Navy defeat Nazi U-boats during World War II. Although the live action filming took only about three weeks to complete, Knotts evidently thought it took forever (in reality, only about two years) to finish the animation, editing, and post-production work.

In 1961, David DePatie became the last executive in charge of the original Warner Bros. Cartoons studio, replacing John Burton. By mid-1962, DePatie was informed that the studio was going to be shut down due to budget cuts and a general decline in theater attendance. The cartoon studio finally closed in the spring of 1963. The final Bugs Bunny cartoon, "False Hare," was completed that year and released in 1964. It was only fitting for Bob to direct this last classic Bugs cartoon. Unfortunately, in addition to the studio

Animation still from *The Incredible Mr. Limpet* (1964), with animation direction by Bob McKimson.

"I Say, I Say . . . Son!"

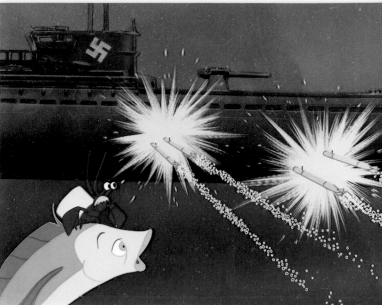

Animation stills from *The Incredible Mr. Limpet* (1964), with animation direction by Bob McKimson.

shutting down in 1963, Bob's loving and supportive wife, Viola, passed away from cancer that year. Bob never quite got over it, nor did he ever remarry.

The full *Looney Tunes* cast is vast and represents some of the best-known and most beloved animated characters that ever existed. One main difference between many of these characters and those from other studios is the voice acting. Thanks mostly to Mel Blanc, the voices of many of the *Looney Tunes* characters are as recognizable as their looks. Who could ever forget Foghorn Leghorn's "I say, I say . . . son!" line or Bugs Bunny's legendary "What's up, Doc?" These characters will be cherished by fans for years to come.

Bob and Viola McKimson, 1960.

Bugs Bunny coloring book cover art by Bob McKimson, 1955.

Chapter Six
Western Publishing
1947-1972

Comic book cover illustration by Tom McKimson, 1981.

Tom McKimson had started doing freelance work for Western Publishing in 1944, illustrating their comic and coloring books. In 1947, he took an indefinite leave of absence from Warner Bros. Cartoons and officially joined Western, where his first assignment was drawing comic magazines.

Tom, whose first love was comic books, followed by coloring books, enjoyed his work at Western immensely, and preferred it over the animation process. He felt that a drawing in a cartoon could only be enjoyed for $1/24$ of a second, while one in a comic or coloring book could be appreciated for an unlimited amount of time. He liked to develop a character and pay special attention to the details—expressive eyes, the right kind of nose, etc. In the beginning of his comic book career, Tom not only provided the original pencil art, but also went on to complete the inking process for the finished comic books. He was proud of his ability to ink and letter, which he did astonishingly well until the day he died.

Tom McKimson, circa 1960s.

Western Publishing was originally founded in 1907 as the West Side Printing Company and officially changed its name to Western Publishing in 1910. Based in Racine, Wisconsin, the company also had editorial offices in New York City and Los Angeles and a printing plant in Pough-keepsie, New York. In 1915, the company bought Hammerung-Whitman Publishing Co., which became Western's subsidiary, Whitman Publishing Company.

Western Publishing had licenses to publish comic books using cartoon characters from Walt Disney Productions, Warner Bros., Metro-Goldwyn-Mayer, Edgar Rice Burroughs, and Walter Lantz Productions. Beginning in 1938, Western's comic books were published under the Dell Comics imprint. Dell handled the financing and distribution of the comics until 1962, when Western established its own label, Gold Key Comics. In the late 1970s the name changed again, this time to Whitman Comics, and the company discontinued its distribution to newsstands, selling its comics only in toy stores from then on.

Western began publishing a wide variety of children's books beginning in the 1920s and '30s, including puzzle and coloring books that were mostly published under the Golden Books and Whitman Publishing imprints. Western also partnered with Simon and Schuster to produce the Little Golden Books, and took complete control of the series in 1958. In 1979, Mattel purchased Western Publishing before selling it off again to investors in December of 1983.

By 1948, Tom had become the art director for the entire line of Dell Comics, Whitman coloring books, and Golden Books. Working with over 100 freelance illustrators and craftsmen, Tom and his team created content for both the comics and the coloring books. Tom had to alter

Above and below: Original artwork for Little Golden Books by Tom McKimson, 1949.

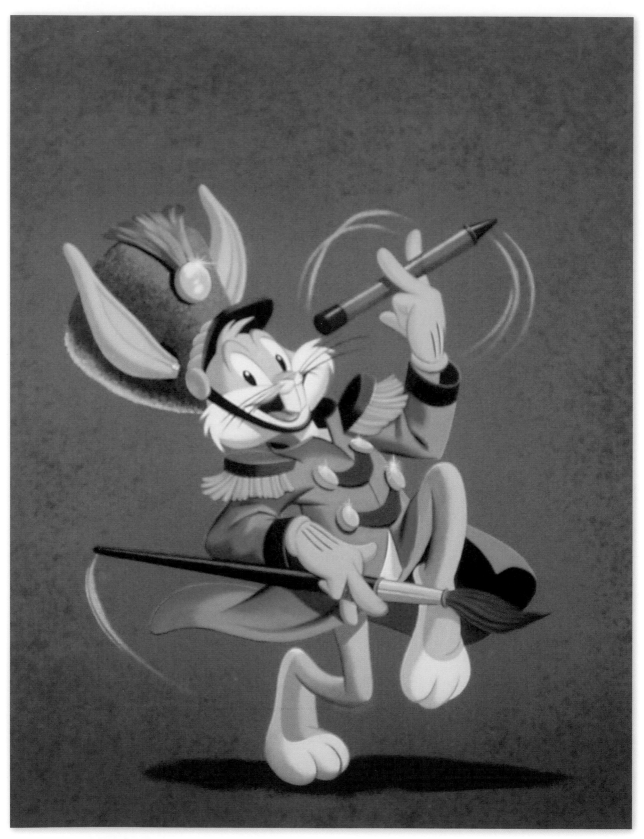

Artwork for Bugs Bunny coloring book cover (above) and interior (opposite) by Bob McKimson.

"I Say, I Say . . . Son!"

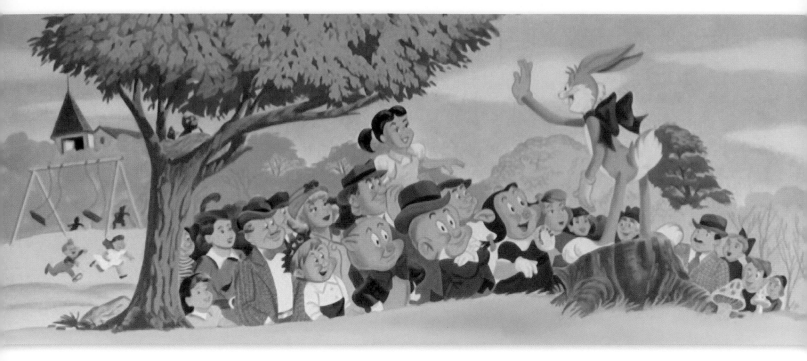

Above, left, and overleaf:
Artwork for Little Golden Books by Tom McKimson.
Opposite: **Drawing for**
Bugs Bunny's Treasure
Hunt **by Tom McKimson.**

"I Say, I Say . . . Son!"

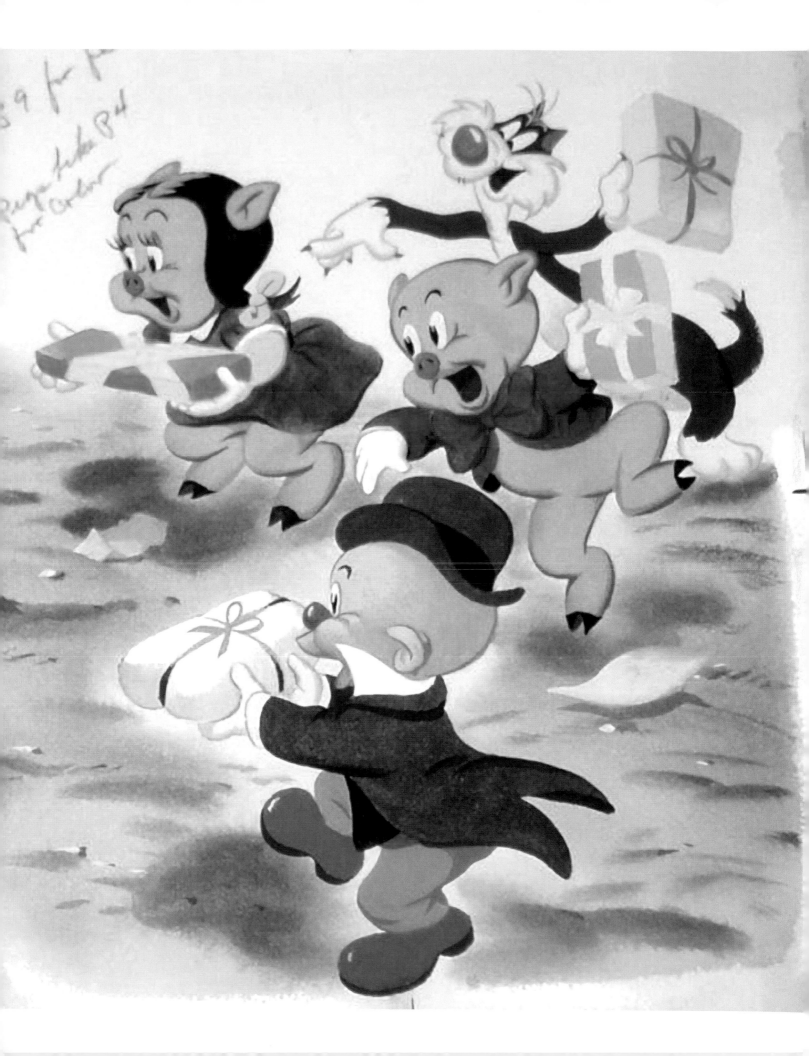

Above and opposite: Original and completed comic book artwork by Tom McKimson, 1980.

"I Say, I Say . . . Son!"

Above and opposite: **Original artwork for Little Golden Books by Tom McKimson, 1949.**

the original model sheets for some of the characters, including Bugs Bunny, to suit the comic books. He later explained that, because you can see each individual drawing in a comic, the detailing had to be more exact than it had been for the animated cartoons.

When Tom made the transition from animation at Warner Bros. to comic magazines and books at Western Publishing, he felt back at home and in his element. Having been raised as a newspaper publisher's son, Tom had literally been born into publishing; up until the time he began working for Walt Disney Productions in 1929, that had been his world. He understood the entire publishing process, from start to finish.

Credits page from a Bugs Bunny coloring book.

Two to three different illustrators can be used in comic book production. One illustrator can do a multi-page segment with a character facing one direction, while another artist does a segment with the same character facing another way. Continuity in art style for any licensed character is of the utmost importance, not only for the property, but also for the reader. Some readers may not notice the difference, but you can't underestimate a child's ability to catch variations in a comic book.

Because the Warner, Disney, and Lantz books focused primarily on cartoon characters, slight variations in character art could be disguised with ink or color. For coloring books, however, Tom always said it was more difficult because the characters are drawn using only lines, with no filler. Coloring books are also more of a challenge because they are so minimalist; the artist has to simplify the drawings so children can handle the task of coloring in the artwork without too much difficulty. For continuity in each coloring book, Tom usually worked with a simple story so the entire book would flow well from page to page.

Because the end product had to be coordinated between Western and the various studios that had contracts with the company, Tom spent a great deal of his time at other studios besides Western. He had the final say when the illustrators presented their finished artwork, but

Original comic book art by Tom McKimson, 1981.

"I Say, I Say . . . Son!"

insisted that the characters should be acceptable not only to him, but also to the other studios. Because of this, Tom had a good rapport with all the studios he worked with, and most companies, such as Disney, were very happy with Western's products. Mattel, however, was very fussy about the paper dolls, coloring books, and games that Western produced for them, and its research and development department was very particular about the look of its characters. But Tom found that if he followed a studio's model sheets faithfully, the end product would be easily approved.

Each of the hundred or so artists Tom worked with had a specialty of some kind. Some were good at facial expressions, while others were particularly adept at drawing certain characters. One artist, Jesse Marsh, did beautiful illustrations of Tarzan. Another, Bill Edwards, created the best cut-out dolls. Tom enjoyed having a whole team of artists to choose from for his projects, and assigned story art identity material to whoever was the specialist in that particular product. He could always depend on this talented "bullpen" of artists to produce quality work.

At Western, hardly a day went by without an artist coming by the studio for a portfolio review, looking for work as a freelance illustrator. Most of them were terrible, but every once in a while Tom saw potential. If the artist could rise to Tom's demanding standards, Tom would hire him. Some of the artists did great pencil drawings but had no inking ability, while others could do inking or lettering work but couldn't draw. Tom's in-house artists spent much of their time cleaning up artwork done by outside animators.

Model sheet for Brad Bunny, a comic book character by Tom McKimson, 1980.

Tom was frequently asked whether there was ever a time when he couldn't come up with a story or variation of a story for a comic book. He always replied that he had some very good story men and that the variety of things they came up with continued to amaze him. Tom did not hold "jam sessions" like the ones at Warner Bros., but instead had special story men assigned to particular types of projects. For instance, Don Christensen was especially good at coming up with elaborate and varied situations for the Western comic books and was Tom's go-to writer for that series.

In the comic book industry, "funny animal" comics, as opposed to "superhero" comics, seem to be perennial favorites. Superheroes come and go, but comical heroes like Bugs Bunny and Mickey Mouse are here to stay. Tom understood that there was always a new group of kids for the comics to appeal to, figuring that about every seven years, a new group of kids came of comic-book age. Accordingly, Western's magazines and books—the Golden Books in particular—could be re-released every seven years to a new group of children.

Tom was also involved in the production of paper dolls, games, coloring books, and comic strips at Whitman Publishing, Western's subsidiary. Beginning in 1948, his brother Chuck had started doing freelance comic book and comic strip work for Tom. From 1949 to 1953, Tom, Chuck, artist Pete Alvarado, and writer Al Stoffel created a Roy Rogers comic strip under the pseudonym "Al McKimson." Although only his last name was included in the credit, this was one of the very few times Tom was ever directly credited for his work. While the comic strip was in production, Tom had a lot of interaction with Western cowboy stars Roy Rogers and Gene Autry, and often drove out to the Southern California desert with them to shoot covers for the comic books.

Tom had frequent run-ins with celebrities when overseeing the artwork for Whitman's paper dolls. When Whitman created dolls in the likeness of Dinah Shore, he had to visit the

Above: Credits page from a *Looney Tunes* coloring book, 1956. *Left:* Whitman Publishing paper doll artwork.

"I Say, I Say . . . Son!"

Looney Tunes coloring book cover by Bob McKimson.

Roy Rogers and Al Stoffel of Whitman Publishing.

actress's house to get her approval on the finished product. Shore would offer criticisms such as, "This eye is not quite right," and, "Couldn't you do something about this ear?" Starlets like Shore, Tom said, would pick on little details like this. When Tom had to visit MGM to get approval for Elizabeth Taylor paper dolls, he would sometimes pull little tricks during his visit, such as attaching a fake sixth finger to his hand just to see if anyone would notice.

When Warner Bros. Cartoons shut down temporarily in 1953, Chuck decided it was time to find a different job. Having done freelance work on the side for Tom, working with his brother full-time seemed to be the next natural step. When a position opened up for an art director in Whitman's comic book department, Chuck jumped at the opportunity and landed the job.

In addition to comics and coloring books, Whitman now also produced paper dolls, games, and the Golden Books. In Chuck's position as art director, he assigned sections of the comic books to different artists to be done in pencil form first. The artists would produce different versions of the pencil drawings until Chuck gave his approval, and then the drawings would be sent to inking.

In 1954, Fredric Wertham's *Seduction of the Innocent* was published and the psychiatrist headed a campaign to censor comic books, leading to highly publicized hearings. The Comics Code Authority was created that year by the comic book industry to regulate the published

"I Say, I Say . . . Son!"

Coloring book artwork by Bob McKimson, circa 1960s.

content. This created various difficulties; for example, at the time the code stated that comic book publishers couldn't depict firearms in their magazines. Since a character such as Elmer Fudd would be nothing without his shotgun, Tom had to find ways to work around this restriction. Another problem was Porky Pig's "nudity." While most of the other characters were covered with fur or feathers, Porky's bare pink skin was considered obscene when unclothed. Although publishers no longer undergo the Comics Code screening process, it has had a significant effect on how cartoons are censored today.

While at Western/Whitman, Tom and Chuck occasionally asked Bob to work on various projects for them at home. This work usually involved drawing characters for coloring books, using pencil on onionskin paper. After Bob's drawings had been approved, an inker would complete the project for printing.

Chuck left Western Publishing in 1960 to work as the animation director for a new television series called *Calvin and the Colonel*, which aired on ABC in 1961 and 1962. This animated cartoon television series was based on the radio and television program *The Amos 'n Andy Show*. The half-hour cartoons featured the original Amos and Andy radio voices of Freeman Gosden and Charles Correll. The featured characters were Calvin Burnside, a brown bear voiced by Correll, and a fox named Colonel Montgomery J. Klaxon, voiced by Gosden. The show was canceled

Above and opposite: **Coloring book artwork by Bob McKimson, circa 1960s.**

206

"I Say, I Say . . . Son!"

Mr. Magoo

Mr. Magoo, who was created by United Productions of America in 1949, made his first appearance that year in the cartoon "Ragtime Bear." A wealthy and retired elderly man, Mr. Magoo has terrible eyesight and gets into all sorts of predicaments because of it. However, due to amazing strokes of luck, he escapes every situation unscathed.

Mr. Magoo, who was voiced by Jim Backus, is one of the few human cartoon characters to have become successful. Beginning in 1964, Bob McKimson directed six episodes of the UPA television series *The Famous Adventures of Mr. Magoo*. In 1977, DePatie-Freleng licensed the character for another series called *What's New, Mr. Magoo?*, with 16 episodes directed in part by Bob.

Above: **Animation still from the series *What's New, Mr. Magoo?* (1977), with animation direction by Bob McKimson.**
Below: **Model sheet for "Moby Dick" (1964) from the series *The Famous Adventures of Mr. Magoo*, with animation direction by Bob McKimson.**

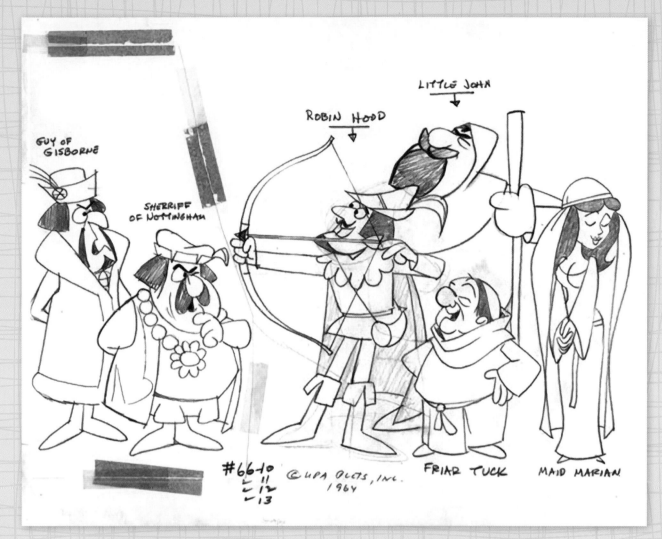

Model sheet (above) and animation cels (below) for "Robin Hood" (1964), from the series *The Famous Adventures of Mr. Magoo* (1964), with animation direction by Bob McKimson.

After Warner Bros. Cartoons shut down, David DePatie and Friz Freleng developed DePatie-Freleng Enterprises to produce animated short subjects. They leased the old Warner Bros. studio, including its equipment and supplies, as their headquarters. In 1964, they contracted with Warner Bros. to produce additional *Looney Tunes* and *Merrie Melodies* cartoons, an arrangement that lasted until 1967. Bob joined DePatie-Freleng in 1964 to direct not only the Warner Bros. cartoons, but all of the other animated short subjects the company was producing at the time as well. At first, the only major change from the old Warner Bros. studio was the name; many of the same personnel from Warner had also joined the new DePatie-Freleng staff. Even Chuck Jones worked at the studio for a short time until he formed his own company and began producing the *Tom and Jerry* series for MGM.

Bob McKimson at his animation desk, early 1960s.

While at DePatie-Freleng, Bob directed a variety of Warner Bros. shorts, including three cartoons released in 1966 and 1967 that featured a new character called the Inspector. Bob also directed the last cartoon DePatie-Freleng produced for Warner Bros., "Daffy's Diner" (1967).

Lobby card for "Daffy's Diner" (1967), directed by Bob McKimson.

The Inspector

The Inspector is a DePatie-Freleng cartoon creation based on the comical French character Jacques Clouseau of the *Pink Panther* films. Although the Inspector is not as inept as Clouseau, he is, unfortunately, prone to bad judgement. Voiced by Pat Harrington Jr., the Inspector wears a trench coat and fedora and usually holds a large magnifying glass while doing his detective work. In total, 34 Inspector cartoons were made for television, all released through United Artists.

Above: Animation still from "Le Quiet Squad" (1967), directed by Bob McKimson.
Below: Animation still from "Toulouse La Trick" (1966), directed by Bob McKimson.

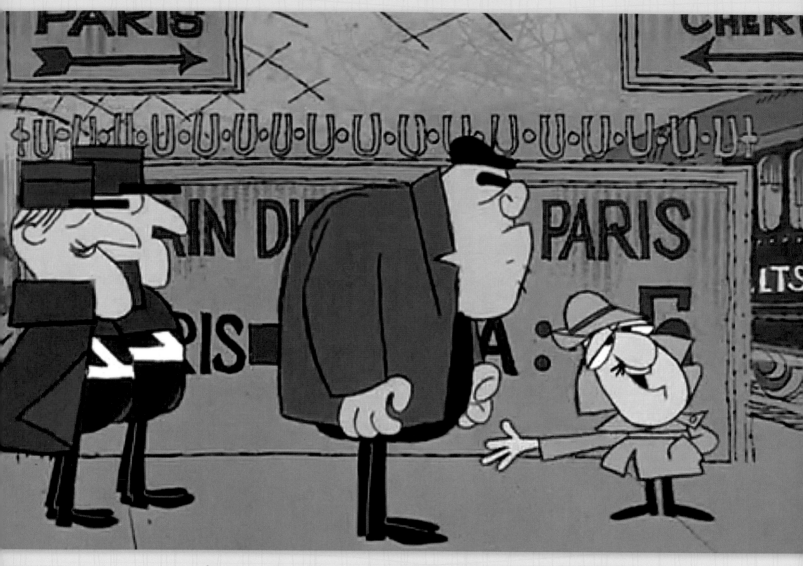

Above: Animation still from "Toulouse La Trick" (1966), directed by Bob McKimson.
Below: Animation stills from "Le Quiet Squad" (1967), directed by Bob McKimson.

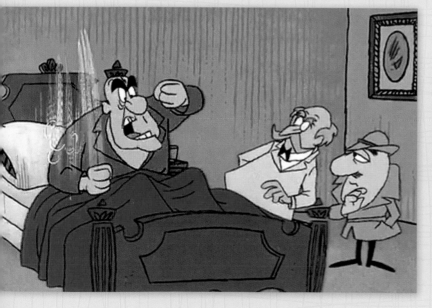

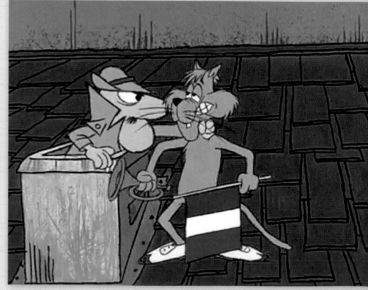

"I Say, I Say . . . Son!"

In 1967, Jack Warner sold his studio to Seven Arts Productions, and the company was renamed Warner Bros.-Seven Arts. The cartoon division opened for business in 1967, in the old location on the Warner Bros. backlot that had been occupied by DePatie-Freleng, which had moved to another location. Warner Bros.-Seven Arts was headed by studio executive William Hendricks and a newly appointed director, Alex Lovy, who had come from Walter Lantz Productions and Hanna-Barbera. Hendricks had tried to get Bob Clampett out of retirement to be the director, but Clampett had refused. However, after about a year Lovy returned to Hanna-Barbera and Bob McKimson replaced him as the director.

Initially, Lovy and his group mainly produced Daffy Duck and Speedy Gonzales cartoons, but soon they were creating new characters like Cool Cat and Merlin the Magic Mouse, along with his assistant, Second Banana. Unfortunately, these new characters were not well-received, so when Bob came to the studio, he drew up his own new characters to use in the cartoons

with the ones Lovy had created. Two of Bob's new characters were Bunny and Claude, a rabbit couple who first appeared in "Bunny and Claude: We Rob Carrot Patches" (1968), a parody of the Warner Bros. movie *Bonnie and Clyde*. Bob also created Rapid Rabbit and Quick Brown Fox, who were first featured in the 1969 release "Rabbit Stew and Rabbits Too!"

Unfortunately, even Bob's new characters couldn't help raise the ratings for the studio's cartoons, and Warner Bros.-Seven Arts ceased production of its cartoon short subjects in 1969. During the short period that Bob worked at the studio, he directed seven cartoons featuring Bunny and Claude, Merlin the Magic Mouse, Rapid Rabbit, and Cool Cat. Sadly, the age of the Warner Bros. classic theatrical cartoon had come to an end.

Drawing of Cool Cat by Bob McKimson, circa 1960s.

Cool Cat

Cool Cat is tiger with a laid-back attitude that contrasts with the excitable nature of his nemesis, a British big-game hunter named Colonel Rimfire. Voiced by Larry Storch, Cool Cat appeared in six classic *Looney Tunes* cartoons.

Cool Cat, first introduced in 1968.

"I Say, I Say . . . Son!"

Merlin the Magic Mouse

Merlin is a traveling magician who performs with the help of his assistant, Second Banana. It is said that Merlin's personality was based on W. C. Fields, and actors Daws Butler and Larry Storch performed the cartoon mouse's voice in that style. Merlin appeared in a total of five classic *Looney Tunes* cartoons.

Size comparison sheet for "Shamrock and Roll" (1969), directed by Bob McKimson.

Quick Brown Fox and Rapid Rabbit

Quick Brown Fox and Rapid Rabbit, both created by Bob McKimson, are archenemies who live in the forest. The ongoing chase scenes, in which Rapid Rabbit always foils Quick Brown Fox's plots to trap him, create a dynamic between the two characters similar to that of Wile E. Coyote and Road Runner. The duo only appeared in one classic *Looney Tunes* cartoon, "Rabbit Stew and Rabbits Too!" (1969).

Above and below: Animation stills from "Rabbit Stew and Rabbits Too!" (1969), directed by Bob McKimson.

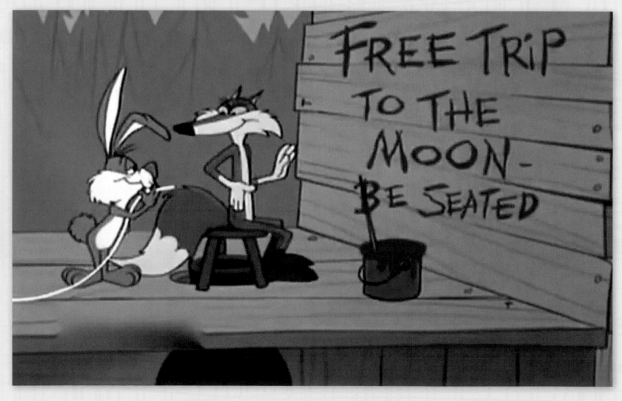

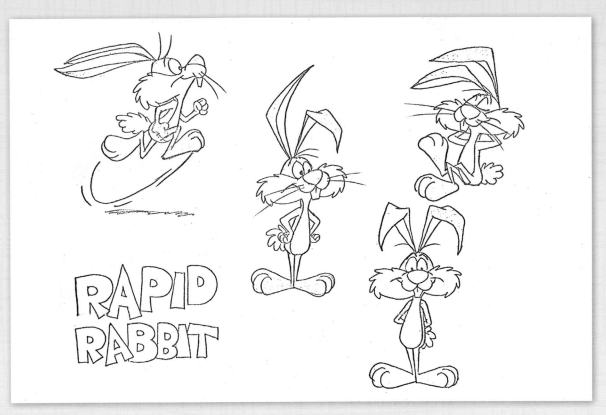

Above and below: **Model sheets by Bob McKimson.**

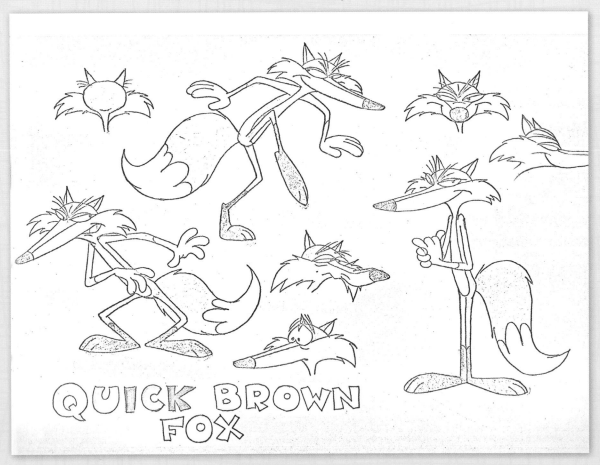

After the studio closed, Bob freelanced for a while, working on commercials, titles, and other animation projects, many of which were referred to him by Tom while he was working at Western. In 1972, Bob rejoined DePatie-Freleng and directed five cartoons released in 1975 and 1976 featuring a new character called the Pink Panther. The character had made his first appearance in the title sequence of the live action film *The Pink Panther* (1963), with animation by DePatie-Freleng. Beginning in the mid-1960s, Bob also co-directed 22 cartoon episodes for television featuring Mr. Magoo.

Drawing (right) for Warner Bros. limited edition Christmas collectors' plate (below) by Bob McKimson, 1977.

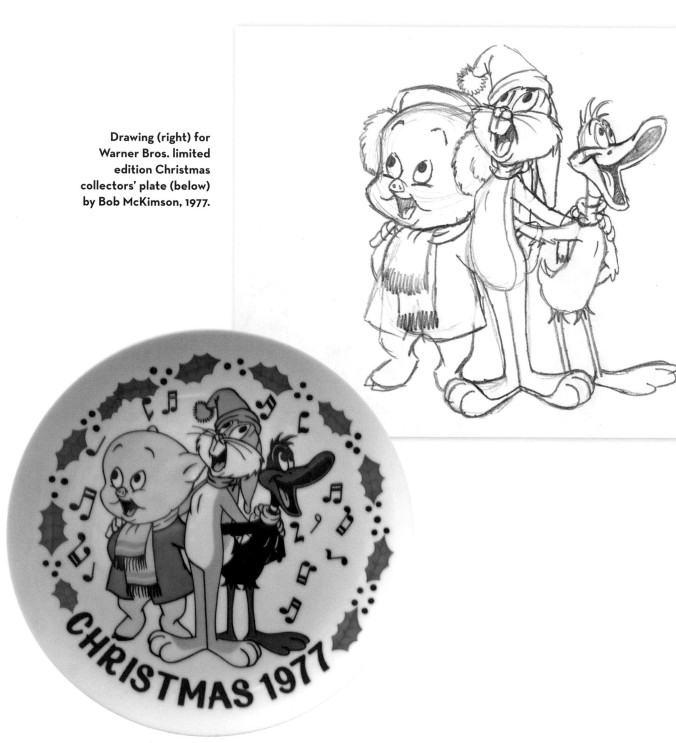

"I Say, I Say . . . Son!"

Pink Panther

The Pink Panther first appeared in the title sequence of *The Pink Panther* (1963), a live action film released through United Artists with animation direction by Friz Freleng. Voiced by Rich Little, the slinky pink cat was such a success that United Artists signed DePatie-Freleng to do a series of theatrical cartoon shorts featuring the character, beginning with the Oscar-winning "The Pink Phink" (1964), directed by Friz Freleng and Hawley Pratt. In 1969, the Pink Panther made his television debut on *The Pink Panther Show*, which was nominated for an Emmy in 1975.

Right: Animation still from "Sherlock Pink" (1976), directed by Bob McKimson.
Below: Animation still from "Mystic Pink" (1976), directed by Bob McKimson.

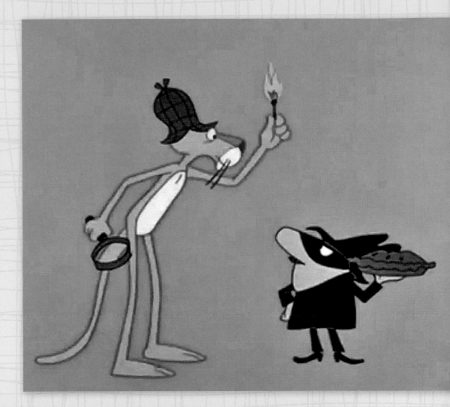

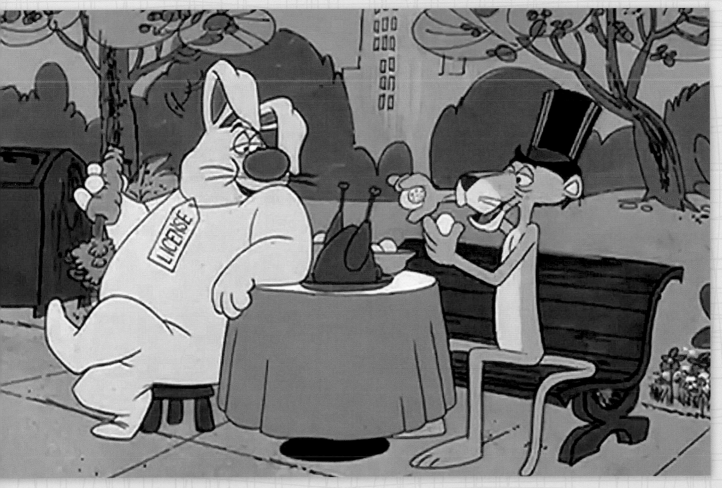

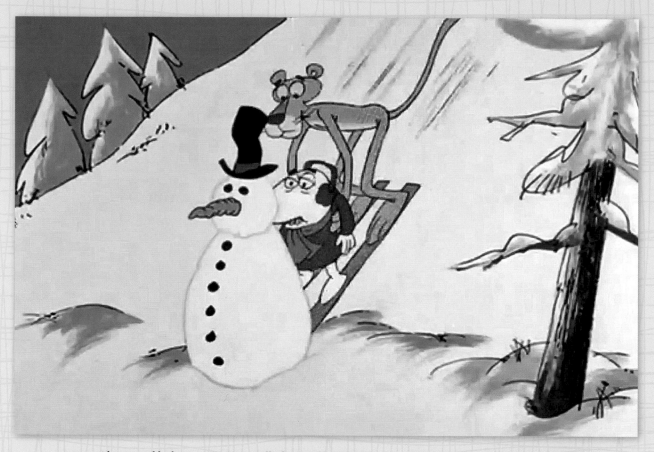

Above and below: Animation stills from "The Pink Pro" (1976), directed by Bob McKimson.

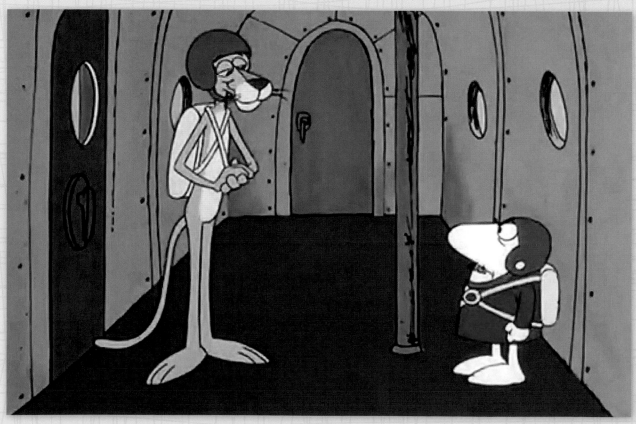

"I Say, I Say . . . Son!"

Bob's final project was the design for the annual Toys for Tots Christmas Drive in 1977, sponsored by the United States Marine Corps Reserve. Bob donated his time and talent to create the posters that were used for the drive, featuring Sylvester Jr., Bugs Bunny, and Bugs's nephew, Clyde Rabbit.

Unfortunately, Bob never got to see the results of his efforts. On September 27, 1777, just two weeks shy of his 67th birthday, Bob suffered a massive heart attack while on his lunch break with Freleng, and did not survive. The longest continual employee at Warner Bros. Cartoons, Bob's accomplishments were many. During his tenure, he animated on over 100 cartoons and directed 175 of them. He created the definitive model sheet for Bugs Bunny, as well as many of the

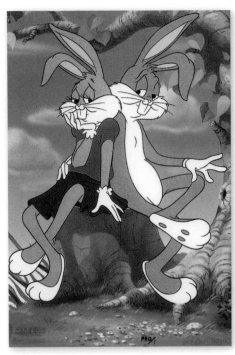

Right: **Limited edition cel of Bugs Bunny and Honey Bunny, from original drawing by Bob McKimson.**
Below: **Bob McKimson and a marine sergeant at the Toys for Tots Christmas Drive, 1977.**

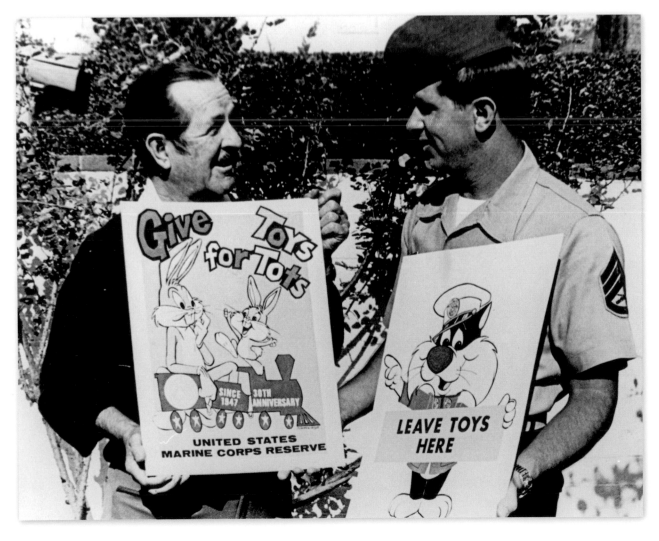

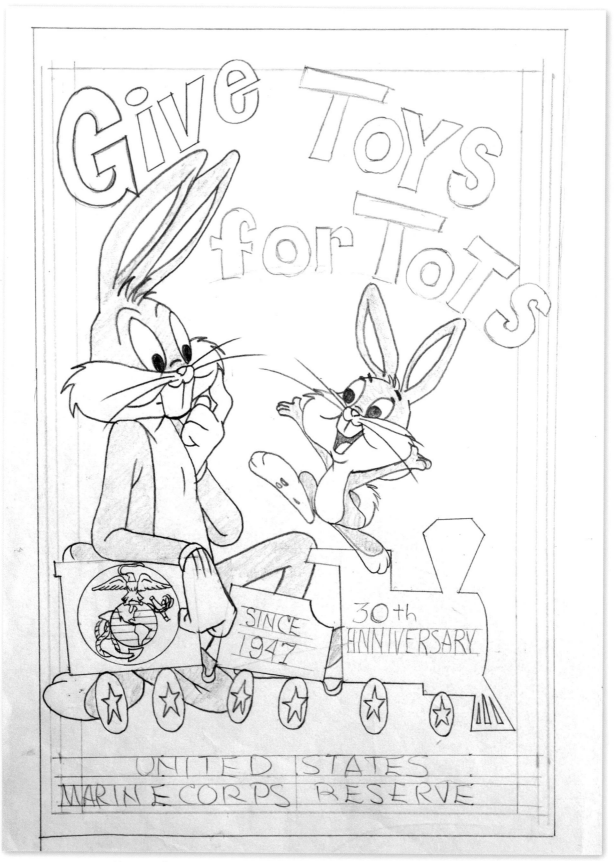

Above and opposite: Drawings for Toys for Tots by Bob McKimson, 1977.

"I Say, I Say . . . Son!"

The sign held by the character reads:

LEAVE TOYS HERE

major *Looney Tunes* characters, including Foghorn Leghorn, Hippety Hopper, Sylvester Jr., the original Speedy Gonzales, and the Tasmanian Devil. Bob also created a little-known character named Honey Bunny, introduced in 1953 as Bugs Bunny's girlfriend. (Honey Bunny was used for merchandising purposes, and never appeared in any of the cartoons. The release of the film *Space Jam* in 1996 introduced Lola Bunny, who essentially took the place of Honey Bunny.) Bob created many secondary characters that played important roles in the *Looney Tunes* cartoons. In 1984, Bob was posthumously honored at the 13th Annual Annie Awards for creative excellence in the field of animation. It was an honor long overdue for Bob, who had been at the forefront of animation since the late 1920s.

Although his career at Warner Bros. was short, Tom worked as either an animator, layout man, or background artist for over 50 of their cartoons. He also created model sheets for many of the studio's characters and played a major role as an animator and layout man for Leon Schlesinger Productions/Warner Bros. Cartoons during the Golden Age of Animation. Tom's contributions helped the studio become a major force in animated short subjects. He passed away on February 14, 1998, just short of his 91st birthday.

During Chuck's tenure at Leon Schlesinger Productions/Warner Bros. Cartoons (which was cut short by his involvement in World War II), he animated on over 90 cartoons and helped Bob create many of the characters. Chuck also worked on animated commercials, as well as movie and television titles. The last of the McKimson brothers to pass, Chuck died on April 16, 1999 at age 84.

The McKimsons' accomplishments and wide range of talents have created a legacy no other three brothers have equaled in their field. Their place in the history of animation and comic book art will forever be recognized and appreciated.

Tom and Chuck McKimson at an art show, mid-1990s.

"I Say, I Say . . . Son!"

Drawings by Bob McKimson, circa 1970s.

Acknowledgments

I want to thank the following individuals, who were instrumental in the creation of this book: photographer Dave Friedman, Ruth Clampett of the Clampett Studio Collections, Rob Clampett of the Bob Clampett Collection, the Abe and Charlotte Levitow Collection, Mike Van Eaton, David DePatie of DePatie-Freleng, Heidi Leigh of Animazing Gallery, Ira Shore of Fine Art Management, Elaine Piechowski of Warner Bros. Worldwide Publishing, animator Art Leonardi, animation historian Michael Barrier, animation art collector Paul Bussolini, Otis Art Institute, and Warner Bros. Image Archives. Special thanks to John Kricfalusi and Darrell Van Citters for their invaluable support and comprehensive knowledge of the animation world.

I would also like to thank Michael Barrier for allowing me to base certain portions of the text on an interview he conducted with my father on May 28, 1971.

Last but not least: Jeffrey Goldman of Santa Monica Press, for his insight in making this book a reality, and his associate, Kate Murray, for doing a magnificent job of editing.

Image Credits